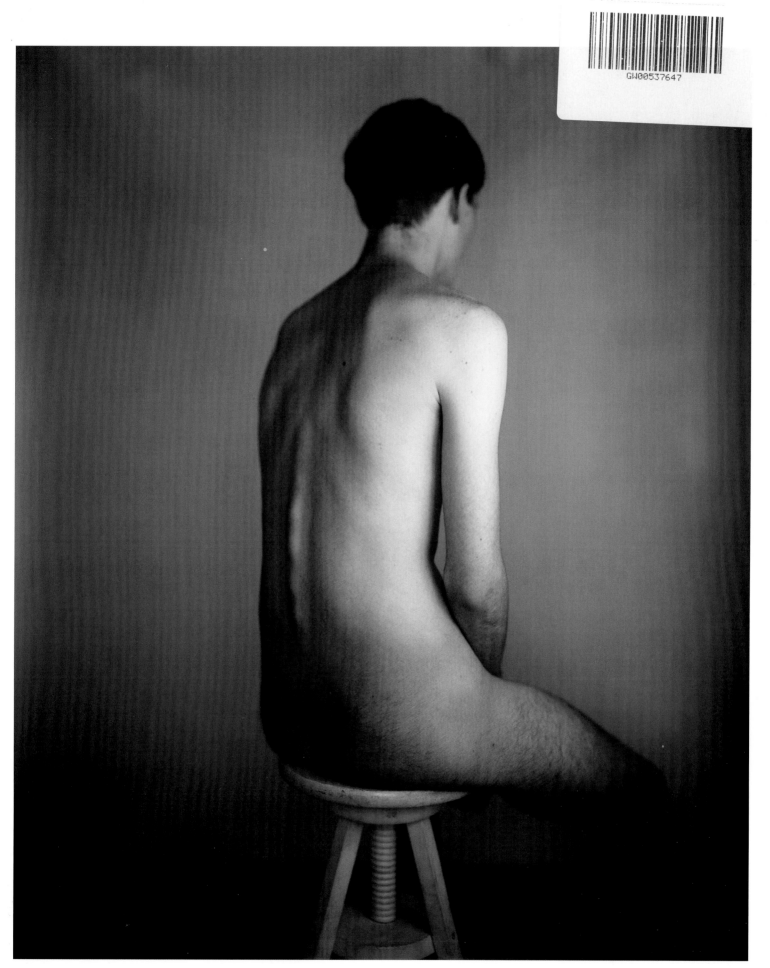

RICHARD LEAROYD *James back 2*, 2011, 58 x 48 inches

WE INVITE YOU TO CONNECT WITH US

Joshua Greenberg
Managing Director, Private Client Advisor
Phone: 212.449.1832
joshua.greenberg@ustrust.com
114 West 47th Street, 6th Floor
New York, NY 10036

Jamie Camhi
Senior Vice President, Private Client Manager
Phone: 212.449.1838
jamie.camhi@ustrust.com
114 West 47th Street, 6th Floor
New York, NY 10036

Art | Basel

Miami Beach | Dec | 3–6 | 2015

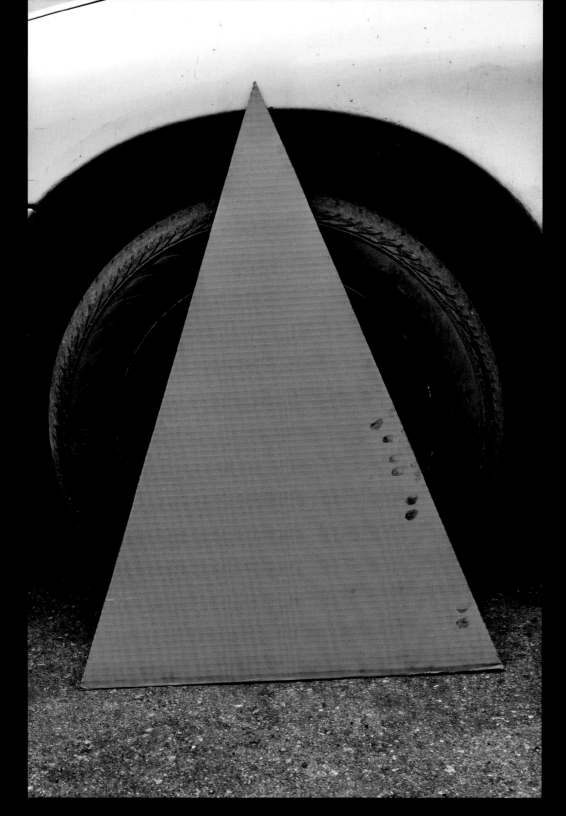

Shannon Ebner: *Auto Body Collision*

More than 150 never-before-published photographs, with essays by Alex Klein,
Tina Kukielski, and Mark Owens. Published by Carnegie Museum of Art.

shop.cmoa.org/ebner

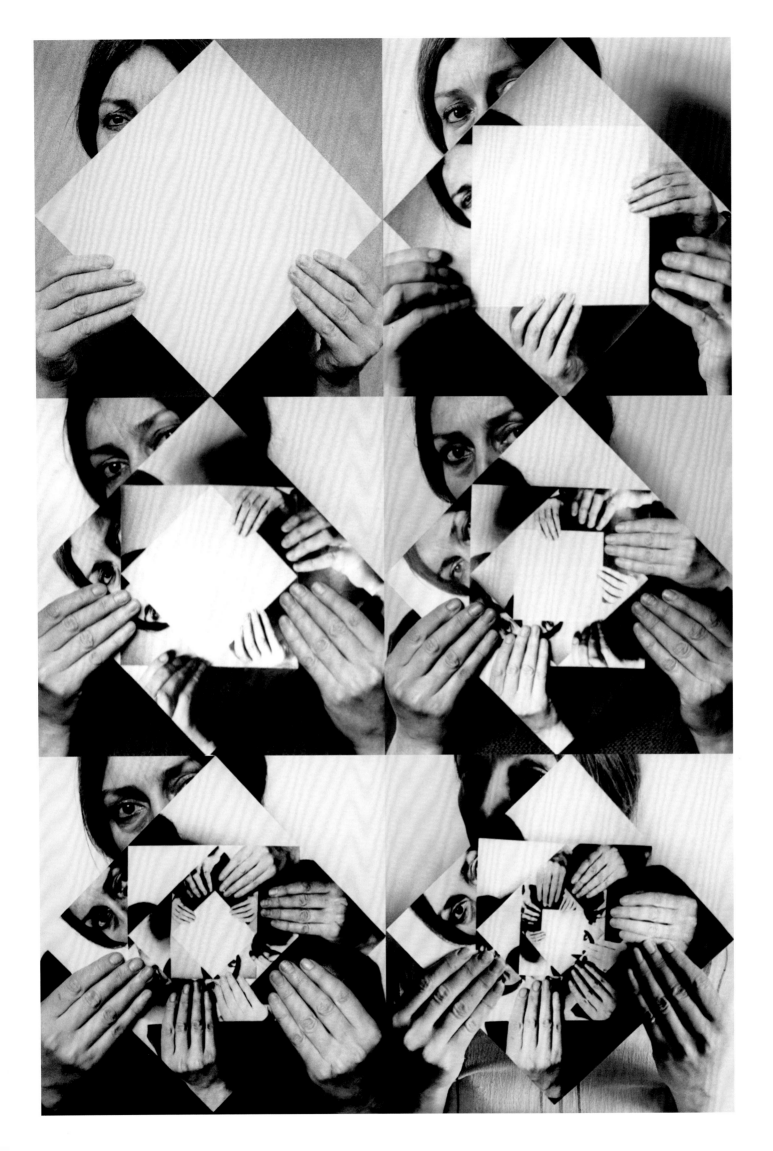

Winter 2015

Opposite:
Dóra Maurer,
Seven Twists I–VI,
1979/2011
Courtesy Vintage Galéria

Front cover:
Helena Almeida,
Inhabited Painting.
Acrylic on gelatin-silver
print, 1975
Courtesy Galería Helga
de Alvear, Madrid

Editor
Michael Famighetti

Contributing Editor
Charles Aubin

Text Editor
Claire Barliant

Editorial Assistant
Victor Peterson, II

Production Manager
Matthew Harvey

Production Assistant
Bryan Krueger

Work Scholars
Sophie Klafter, Nicole Maturo, Melissa McCabe, Cassidy Paul

Art Direction, Design & Typefaces
A2/SW/HK, London

Editor-at-Large
Melissa Harris

Publisher
Dana Triwush
magazine@aperture.org

Partnerships and Advertising
Elizabeth Morina
917-691-2608
emorina@aperture.org

**Executive Director,
Aperture Foundation**
Chris Boot

Minor White, Editor (1952–1974)

Michael E. Hoffman, Publisher and Executive Director
(1964–2001)

Aperture, a not-for-profit foundation, connects the photo community and its
audiences with the most inspiring work, the sharpest ideas, and with each other—
in print, in person, and online.

Aperture (ISSN 0003-6420) is published quarterly, in spring, summer, fall, and winter,
at 547 West 27th Street, 4th Floor, New York, N.Y. 10001. In the United States,
a one-year subscription (four issues) is $75; a two-year subscription (eight issues)
is $124. In Canada, a one-year subscription is $95. All other international subscriptions
are $105 per year. Visit aperture.org to subscribe. Single copies may be purchased
at $24.95 for most issues. Preview the *Aperture Digital Archive* at aperture.org/archive.
Periodicals postage paid at New York and additional offices. Postmaster: Send address
changes to *Aperture*, P.O. Box 3000, Denville, N.J. 07834. Address queries regarding
subscriptions, renewals, or gifts to: *Aperture* Subscription Service, 866-457-4603
(U.S. and Canada), or email custsvc_aperture@fulcoinc.com.

Newsstand distribution in the U.S. is handled by Curtis Circulation Company,
201-634-7400. For international distribution, contact Central Books, centralbooks.com.

Help maintain Aperture's publishing, education, and community activities by joining our
general member program. Membership starts at $75 annually and includes invitations to
special events, exclusive discounts on Aperture publications, and opportunities to meet
artists and engage with leaders in the photography community. Aperture Foundation
welcomes support at all levels of giving, and all gifts are tax-deductible to the fullest extent
of the law. For more information about supporting Aperture, please visit aperture.org/join
or contact the Development Department at membership@aperture.org.

Library of Congress Catalog Card No: 58-30845.

ISBN 978-1-59711-324-3

Printed in Turkey by Ofset Yapimevi

Aperture magazine is supported in part by an award from the National Endowment for
the Arts and with public funds from the New York City Department of Cultural Affairs
in partnership with the City Council.

aperture.org

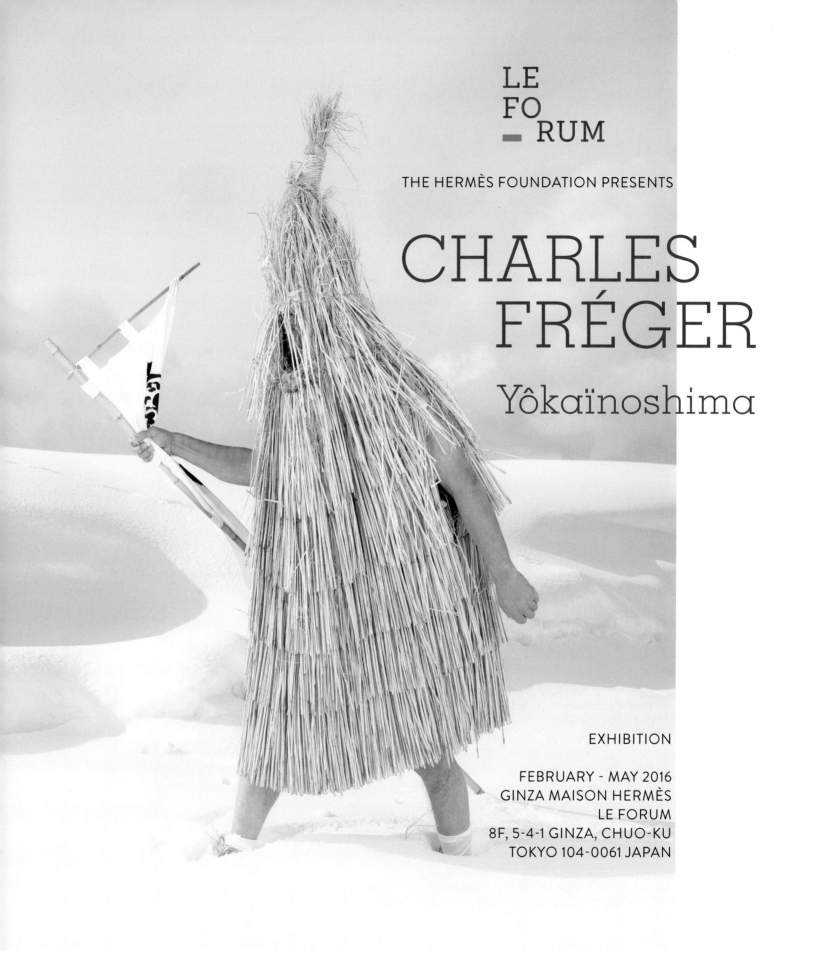

LE FO _ RUM

THE HERMÈS FOUNDATION PRESENTS

CHARLES FRÉGER

Yôkaïnoshima

EXHIBITION

FEBRUARY - MAY 2016
GINZA MAISON HERMÈS
LE FORUM
8F, 5-4-1 GINZA, CHUO-KU
TOKYO 104-0061 JAPAN

www.fondationdentreprisehermes.org

FONDATION D'ENTREPRISE HERMÈS

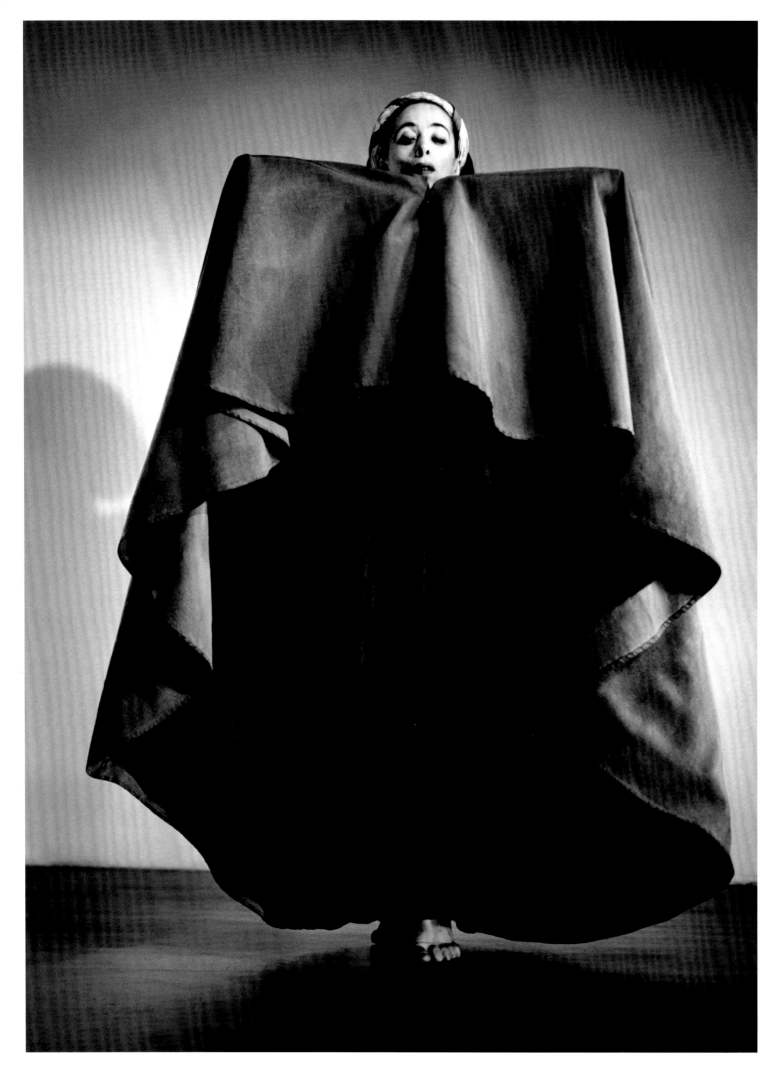

Performance

Observing the photographer Henri Cartier-Bresson, Truman Capote remarked, in a now famous quote, that the acclaimed photographer was "dancing along the pavement like an agitated dragonfly, three Leicas swinging from straps around his neck, a fourth one hugged to his eye: click-click-click (the camera seems a part of his own body), clicking away with a joyous intensity, a religious absorption." As Capote makes clear, the act of photographing *is* a performance. Indeed, from the early years of the medium, with Hippolyte Bayard's 1840 staged *Self-Portrait as a Drowned Man*, to contemporary artists using Instagram and other social-media platforms, the impulse to perform is threaded throughout photography's history and evolution.

This issue, a collaboration between *Aperture* and Performa, the nonprofit organization dedicated to exploring the critical role of live performance in visual art, takes a capacious approach to considering the intersections of the two mediums, from recording an event staged by an artist to role-playing for the camera. Over the past decade, Performa has curated an international biennial of performance mounted in sites throughout New York City. Contributions here, such as portfolios by Carrie Mae Weems and the Hong Kong–based duo Zheng Mahler, reflect Performa's work and programming for their current biennial, which opened in New York earlier this month.

While the photograph's relation to performance is often described as mere documentation, creating a lasting record of a short-lived event, there's more to the story. The photograph at left—one of Barbara Morgan's enduring images of choreographer Martha Graham in motion—illustrates how a photograph can continue to "perform" long into the future, transcending its role as document. As Performa director RoseLee Goldberg notes in her conversation with Museum of Modern Art curator Roxana Marcoci, performances are often crafted for the camera to create an unforgettable image. Goldberg also observes how, in turn, the history of live performance has left its mark on still photography. That reciprocity is echoed in Tate curator Simon Baker's article examining photographic history through the lens of performance. Invoking a wide range of examples, from collaborative duo Shunk-Kender, who bore witness to all manner of performance works of the 1960s and '70s (including Yves Klein's iconic *Leap into the Void*), to Eikoh Hosoe's collaborations with a butoh dancer, Baker characterizes his article as an "attempt to walk (and blur) the line between the photography of performance and performative photography." The octogenarian Portuguese artist Helena Almeida, whose *Inhabited Painting* (1975) appears on our cover, was also intent on blurring lines: her playful images might be considered paintings, actions, and performative photographs, as well as documents.

Elsewhere in the issue history is performed, in Samuel Fosso's impersonation of Mao Zedong, and through the lecture format in the works of a group of Lebanese artists, including Walid Raad, Rabih Mroué and Lina Saneh, and Joana Hadjithomas and Khalil Joreige, who have all deployed this form to reflect on fraught histories as well as the limits of photography's documentary capacity. These works are far from embracing the idea embodied by midcentury figures like Cartier-Bresson that a truth, or a moment in history, might be compressed into a single, elegantly organized frame—instead, the moment that matters is the live experience of looking at images in an environment where photographs, as author Kaelen Wilson-Goldie observes, "act more like elements in live theater or literature." In that sense, then, the expanding ways in which we might consider the photographic in performance and the performative in photography continue to offer new opportunities to reflect on complex contemporary narratives. — The Editors

WE HAVE A DIFFERENT WAY
OF LOOKING AT **PHOTOGRAPHS**

You won't find the same old same old at Swann Auction Galleries. Our departments assemble sales that are unusually rich. In fact, we were the first American house to offer photography sales, and our Photographs & Photobooks specialists remain innovators in their field. Swann understands more than art and books, we understand you, whether you're a lifelong collector, a first-time buyer, or looking to sell. We approach auctions with a blend of high-brow knowledge and low-brow fun. For a different perspective on auctions, come to Swann. We create our own culture.

Collectors
The Musicians
On Recent Acquisitions

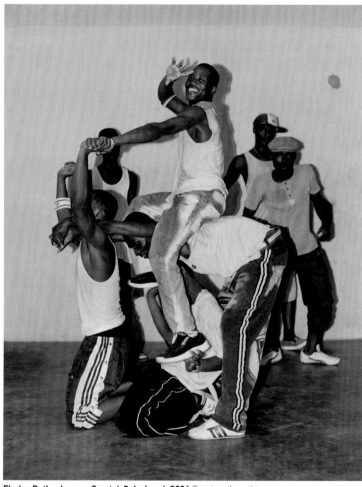

Flurina Rothenberger, *Scratch Boiz, Lomé*, 2006 Courtesy the artist

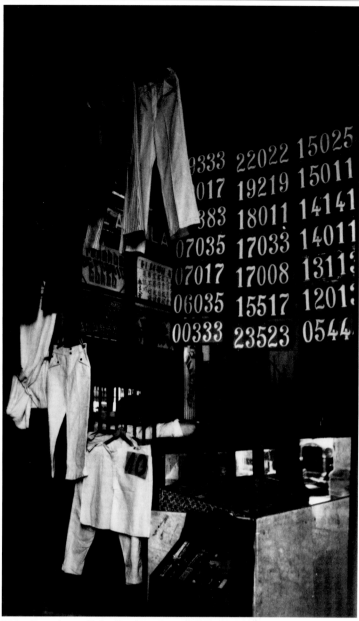

Walker Evans, *Lottery Ticket Shop Signs, Havana*, 1933 © Walker Evans Archive, The Metropolitan Museum of Art and courtesy Art Resource, New York

Devonté Hynes

This photograph is from Flurina Rothenberger's 2015 book *I Love to Dress Like I Am Coming from Somewhere and I Have a Place to Go*. It spans ten years of her photography (2004–14) in Africa. I was in the SoHo bookstore McNally Jackson with my friend who was buying it as a birthday gift for someone else. The images were instantly striking to me. Whereas other books and photographs of similar subject matter can come across as glorification or cultural tourism, I did not get that sense from looking at these pictures. I felt genuine respect and care for her subjects.

This photograph, besides being visually so strong with its shapes and pastel colors, is full of so much joy and creativity. It shows a side of Africa that is generally not portrayed in Western culture. It makes me smile every time I look at it in the book.

Devonté (Dev) Hynes is a producer, songwriter, and artist based in New York City. He performs under the name Blood Orange.

Andrew Bird

I first saw this photograph used as the cover to Graham Greene's 1958 novel *Our Man in Havana*. It was cropped so that only the bingo numbers filled the frame. I've been fixated by it ever since and I can't put my finger on why. The novel credited it as *Bingo Numbers in Havana*, so I tracked down the book *Havana 1933*, by Walker Evans. Both versions interest me but it was the cropped version that grabbed me. I have both the novel and the Evans book. There's something satisfying about numbers, symbols, characters, code— anything that needs deciphering— as a background. I suppose I've never spoken the language of numbers. They are Sanskrit to me, and when you don't know a language maybe you can better appreciate its shape.

Andrew Bird is a Chicago-based composer. His latest release is *Echolocations: Canyon* (2015).

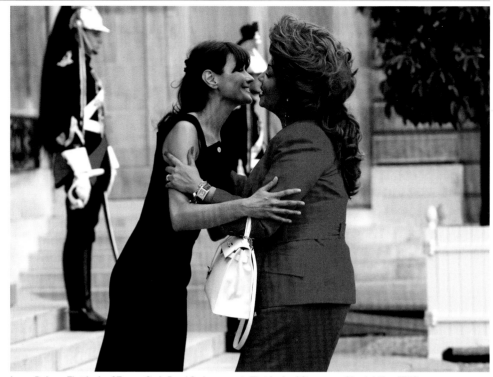

Lucas Dolega, First Lady of France Carla Bruni-Sarkozy greets First Lady of Cameroon Chantal Biya, 2010
Courtesy epa/Lucas Dolega

Fatima Al Qadiri

I dub this image *When Carla Met Chantal*. In a wormhole search online for "Chantal Biya," I came across this telling double portrait of the kind of chic, diplomatic awkwardness that can befall a first ladies' exchange. Carla Bruni-Sarkozy appears minimalist and unadorned in a somber black dress while Chantal is a tower of blazing artifice, fiery shades emanating all the way to her nails. The effusive smiles and steel grip of their hands reveal a terrifying exaggeration of warmth in the face of stiff, cold protocol. And with France being the former colonial ruler of Cameroon, a strained historical embrace is captured and immortalized.

I'm a member of an art collective called GCC; our work is primarily inspired by government activities and diplomatic rituals. I download a lot of images of diplomatic situations. This image of these two first ladies says a lot about power, postcolonial relations, taste, posturing, and representations of femininity that I personally find fascinating.

Fatima Al Qadiri is a Kuwaiti music producer and artist. She has performed and exhibited at MoMA PS1 and the New Museum, among other places.

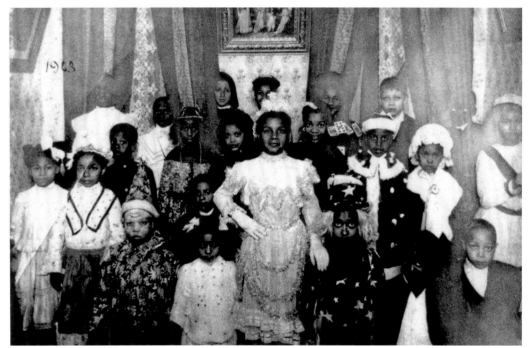

Postcard from Weeksville Heritage Center, Brooklyn, New York

Kyp Malone

I picked this postcard up at the Weeksville Heritage Center, a historical museum devoted to the preservation of one of America's first free black communities, when I performed there a year ago on the invitation of the nonprofit public-art organization Creative Time, which organized a series of exhibitions at or near the site. It was one of a small number of cards chronicling old-timey black Brooklyn. It's been on and around my desk all year while I've written and recorded music, and it's had the effect of a small, warm haunting. I presume these kids were dressed up for a Halloween celebration. Their distinct

personalities and expressions speaking to varied experiences are captured in this moment. So many stories happening in that room. Little girl center frame is the star, but look around her at all the planets, moons, comets. A tiny pantheon. This is from 1903, when antiblack mob violence and lynchings were regular occurrences in this country, certainly not too far from the consciousness of the parents who dressed them up, and likely already polluting their young lives. But here in this photograph is a moment of creative free play, of imagining, of world making. As we do.

Kyp Malone is a singer and guitarist for the band TV on the Radio.

FUJIFILM

X-SERIES
DIGITAL CAMERAS

Photo © 2015 Bill Fortney | FUJIFILM X-T1 Camera and XF18-55mm F2.8-4 R LM OIS lens, at 0.6 sec at F/20, ISO 100.

Inspiring places can fuel a
Passion...

X-T1

X-T10

"I am celebrating my 46th year as a professional photographer. I have fallen in love with the incredible Fujifilm X-Series. Being an "old school" guy, I love the retro controls. Fujifilm has always been a master of color reproduction and the X-Series captures that look and feel with its cameras and drop dead gorgeous lenses. Fujifilm X-Series has brought back the joy and excitement to my photography! ".
-Bill Fortney

www.FujifilmExpertXT1bfortney.com
facebook.com/fujifilmcameras 👍
FujifilmUS 🐦

Sometimes a Chair is a Great Idea.

Maryland Institute College of Art introduces The Stuart B. Cooper Endowed Chair in Photography.

The first of its kind, The Stuart B. Cooper Endowed Chair in Photography will appoint distinguished artists committed to enhancing art photography and shaping the next generation of artists at MICA.

For additional information please contact the Photography Department head, Regina DeLuise at rdeluise@mica.edu

Image credit: © Sb Cooper, *Chaired*, 2015

MICA.edu/bfaphoto

MARYLAND INSTITUTE COLLEGE OF ART

Curriculum
A List of Favorite Anythings by Robert Cumming

Robert Cumming (b. 1943) has long identified as a painter, sculptor, photographer, mail-art practitioner, and performer. His multidisciplinary tendencies reach an apex in his photographs, often of careful constructions, which are laced with mystery and mischievous humor. Whether scoring a toast-shaped incision into a watermelon—one of his best-known images—or building a staircase to nowhere, Cumming frequently probes the limits of the imagination. "Life can be weird," Cumming wrote to us recently. "While I was putting the finishing touches on this piece, Massachusetts General Hospital asked me if I would consider donating my brain for neurological research." Aperture will publish a book of his photographic work next spring.

Bubble chamber photographs

Over the years, I've tried to keep up with advances in physics. The scale physics describes is so infinitesimally small and at the same time unimaginably large, it is hard to wrap one's mind around it. When I was an undergraduate art student in the mid-1960s, the first bubble chamber photographs started to appear in science magazines: black-and-white traces of atom-splitting experiments. They were simply gorgeous and graphically stunning, almost like grainy blackboard diagrams.

Charles Currier's large glass plate photographs

In 1964, a teacher at Mass. College of Art in Boston took us to Brandeis's Rose Art Museum to see a show of the new Color Field painters—Louis, Noland, Stella, Poons, et al.—huge nonrepresentational canvases that to me seemed vast. Then I wandered into a small neighboring gallery and was even more blown away by a show of nineteenth-century photographs by Charles Currier. The large plate prints (20 by 24 inches) and the details therein were just as stunning as the canvases. The prints simply glowed—I'd never seen anything like them.

Giovanni Battista Piranesi, view of the Colosseum (1776) and *Carceri* (1749–60)

In art school, I invented mechanical landscapes in pen and ink: steel I-beams, plates, cables, and rivets stretching out to the horizon. A painting instructor congratulated me on discovering Piranesi in the library, where I also found the artist's threatening *Carceri d'Invenzione* (Imaginary prisons). I was enthralled by his prints of Roman ruins, especially a view of the Colosseum, which crowded the picture space to its margins. As a youth, Piranesi was sent to work with his uncles who specialized in Baroque opera sets—yet another connection between the eighteenth-century visionary and myself when, fifteen years later, I started photographing movie soundstages.

Alain Robbe-Grillet, *In the Labyrinth* (1960)

Peculiar tale about a soldier wandering through a virtually empty city much like the bombed-out European cities after World War II (also see Graham Greene's *The Third Man* [1950], both the novel and film). Endless disembodied, topographic descriptions of things. Eerie snow dusts the black city, dust motes fall on the interiors, but the more the descriptions pile up, the less the reader, like the soldier, is sure of where, exactly, he is.

Robert Frank, *The Americans* (1955–57)

After moving west in 1970, I found it easy to play on the follies of Hollywood. While I focused objectively on the materials, i.e., the nuts and bolts, Frank's series *The Americans* presented a humanistic side of the coin. His poignant *Movie Premiere, Burbank* is dominated by a beautiful, out-of-focus blonde, who turns out to be a foil for three blue-collar women in the background. While critiquing socioeconomic class divisions, Frank's humanity always tipped the scale in the direction of the little guy, cutting across social strata.

Emily Dickinson, second stanza of "The difference between Despair" (1863)

The mind is smooth—No motion—
Contented as the Eye
Upon the Forehead of a Bust
That knows—it cannot see—

The smooth mind in its dark, moist enclosure. The eye in its own wet socket looking out at a marble bust but unable to see…because it is marble and not flesh? Or is this the inanimate marble eye of the bust content in its own blindness? The simple four lines lurch off into a slow spin of fascinating cerebral conundrums. Who sees? Who cannot see? Is the entire scenario being described from the vantage point of an outsider? The motionless mind hums away, considering the numerous possibilities.

Sappho's poetry (sixth century BCE)

Greek papyrus scrolls were written on long horizontal rolls. A century or two later, Egyptians ripped these into long strips and made them into cartonnage coffins, wadded and stuffed them into the mouths of mummified crocodiles, or simply threw them away. These fragments are now being discovered, including works by the Greek poet Sappho. Often shorter than haiku, they are poignant, magical. I still get a lump in my throat when reading them.

Thomas Eakins's perspective studies for rowing pictures (1872–74)

It defies belief that Eakins's rowing pictures, which are so casually, yet convincingly, "photographie," were laboriously built up from dozens of measured perspective studies.

The Master of Mary of Burgundy, *Illustrated Prayer Book* (circa 1500)

The biblical hero David fights a lion with its paws on a beehive. This suggests some connection with the story of Samson, who found a swarm of bees in the corpse of a lion he had just killed. The page size of the manuscript is smaller than a standard postcard and the picture within not much larger than a postage stamp. There is something "thorny," darkly Middle Ages–like, about visions of bees living in other organisms.

Rereading

A few years ago I launched a project to reread some of the books I thought had special meaning—to see if they still held up after all these years. The titles that continue to resonate with me now number twenty-five. I've read Homer's *Iliad* three times and Paul Theroux's *The Mosquito Coast* (1981) four times and they both still knock me out. Theroux tracks the inevitable dissolution of work-ethic Yankees who ultimately unravel in the Honduran tropics. Conrad employed the same literary device in *Heart of Darkness* (1902), which I borrowed a paragraph from for a site-specific installation at MIT, titled *Blackboard Brain* (1993). It included foot-high chalk letters against a floor-to-ceiling grid, mixed with silhouettes (from the very small to the enormous) of objects like pens or scissors. The work was meant to evoke the effect of having wandered into someone's mind. Chalk dust fell silently to the floor, conjuring erasures or the loss of memory.

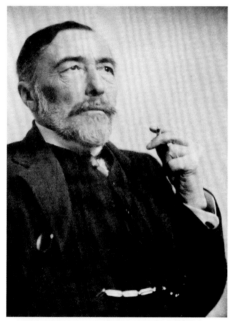
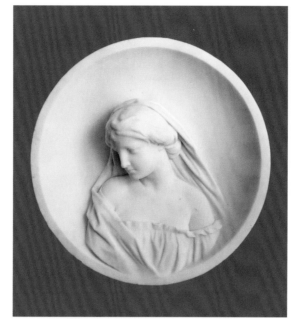
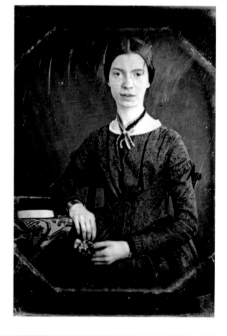

An Evergreen Black Cat Book $2.45
BC-69

Two Novels by
Robbe-Grillet
(Jealousy)
& (In the Labyrinth)

1

2

3

4

5

6

7

8

9

10

11

12

1 Irving Penn: Beyond Beauty; Merry A. Foresta; Distributed for the Smithsonian American Art Museum in association with The Irving Penn Foundation **2** The Power of Pictures: Early Soviet Photography, Early Soviet Film; Susan Tumarkin Goodman and Jens Hoffmann; Published in association with the Jewish Museum, New York **3** That Day: Pictures in the American West; Laura Wilson; Published in association with the Clements Center for Southwest Studies at Southern Methodist University **4** Jacob A. Riis: Revealing New York's Other Half, A Complete Catalogue of His Photographs; Bonnie Yochelson; Published in association with the Museum of the City of New York **5** Portraits: The Human Clay; Lee Friedlander; Distributed for the Yale University Art Gallery **6** Children: The Human Clay; Lee Friedlander; Distributed for the Yale University Art Gallery **7** Warhol & Mapplethorpe: Guise & Dolls; Edited by Patricia Hickson; Published in association with the Wadsworth Atheneum Museum of Art **8** Indecent Exposures: Eadweard Muybridge's "Animal Locomotion" Nudes; Sarah Gordon **9** Multitude, Solitude: The Photographs of Dave Heath; Keith F. Davis; Distributed for The Nelson-Atkins Museum of Art **10** Germaine Krull; Michel Frizot; Distributed for Editions Hazan **11** In Front of Saint Patrick's Cathedral: A New Edition; Donald Blumberg; Distributed for the Yale University Art Gallery **12** Words and Images from the American Media; Donald Blumberg; Distributed for the Yale University Art Gallery

Yale UNIVERSITY PRESS

art + architecture
yalebooks.com/art

On Portraits
Geoff Dyer

In this regular column, Dyer considers how a range of figures have been photographed. Here, he reflects on an image of the influential curator John Szarkowski.

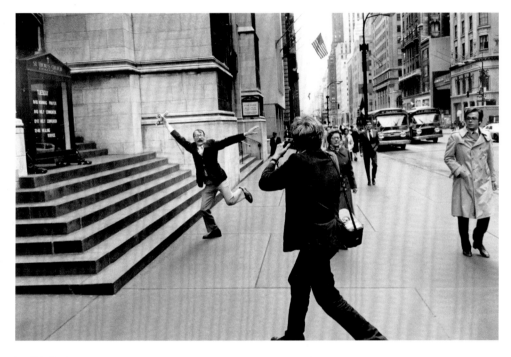

Lee Friedlander,
*Garry Winogrand
and John Szarkowski,
New York City,* 1975
© Lee Friedlander /
courtesy Fraenkel Gallery,
San Francisco

Geoff Dyer's new book
*Where Do We Come
From? What Are We?
Where Are We Going?*
will be published by
Pantheon in the spring.

For students of photography, this picture is of obvious and multilayered interest. Taken by Lee Friedlander in 1975, it shows John Szarkowski, head of photography at the Museum of Modern Art, striking a pose as Garry Winogrand takes his picture. So the organizer of the groundbreaking 1967 *New Documents* show at MoMA, and two of the three photographers featured in it, each play a part in this document. (The third photographer, Diane Arbus, had killed herself four years previously.)

For students of tennis, however, this image from 1975—the year that Arthur Ashe beat Jimmy Connors to become Wimbledon champion— is also a demonstration of what makes a successful tennis photograph, more specifically, how certain photographs of Roger Federer perfectly convey the perfection of Federer's game.

There has been much impassioned debate as to whether Federer is the greatest tennis player of all time. What can be said with certainty is that he was, for a while, the greatest player of *his* time. With similar confidence Szarkowski deemed Winogrand "the central photographer of his generation."

I don't know how long Szarkowski was able to hold his pose. Only briefly, I'm guessing, but there was plenty of time for the fast-thinking Winogrand to get the picture—and for Friedlander to get the picture of Winogrand getting the picture.

I first saw this photograph in the house of photographer Thomas Roma, who pointed at Winogrand and said, "Look at the way that his weight falls on the front foot, how he's able to advance the film, bring the camera to his face to create a momentarily stable platform for the shot while moving forward." Winogrand is in motion but is able to create the necessary fleeting stillness. Change a few words in Roma's observation and you could be reading a passage from a manual instructing students how to hit a perfect tennis shot. (Joel Meyerowitz, a protégé of Winogrand's, remembers learning from him "the kind of moves that were necessary to get to a picture." Not *get a picture*, note, but get *to* a picture, with the emphasis on movement, on footwork.)

The tennis player's stillness in the midst of motion—"still and still moving," in T. S. Eliot's famous words— is most perceptible in the execution of Federer's backhand. Look at how he keeps his head down for a fraction of a second after he's completed the shot. The platform is as stable as possible for as long as is compatible with endless flowing movement. (Of Winogrand's particular way of taking a picture, Meyerowitz recalls that "the camera and his eye would meet just for the moment in a kind of glancing bow.")

The Bronx-born Winogrand had more in common temperamentally with the belligerently attritional and uncompromising Connors than with the suave Federer or the eloquent Ashe. He photographed American football games and, as far as I know, showed little interest in tennis. But to study his work is to see an endless succession of still movement: a one-way rally between Winogrand and the street in which he held court.

UNTITLED, Miami Beach,

Dec 2,3,4,5,6, 2015.

Located at
Ocean Drive &
12th Street.

art-untitled.com

Redux
Rediscovered Books and Writings

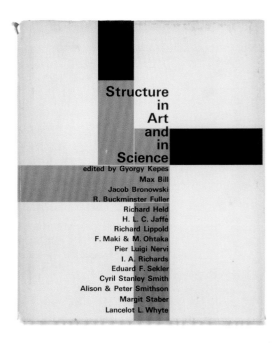

In these classic volumes, art and science became one.

The *Vision + Value* Series
Jimena Canales

An electron micrograph of a virus. Ansel Adams's photograph of magnetic core memory. A photograph of a thirteenth-century mosaic in Ravenna. What do these three images have in common? All of them look uncannily alike, and resemble patterns or graphs that emerge from mathematical exercises. And all are found in the *Vision + Value* series (1965–66), edited by Hungarian artist, photographer, designer, and theorist Gyorgy Kepes. In six beautifully illustrated volumes he sought to compile "the best knowledge of a given time."

Kepes explained how he admired the vast advances in the creation and circulation of knowledge that had taken place in the previous several decades, yet he lamented the separation between the eye, heart, and brain. His solution was a new term that he coined, *interseeing*. The series was an ambitious endeavor, "a kind of laboratory experiment," undertaken to "remake our vision" in its entirety. The books combined scholarly texts with images and photo-essays by a star-studded cast of artists, architects, philosophers, and scientists, including Paul Rand, Ad Reinhardt, Buckminster Fuller, Marcel Breuer, Marshall McLuhan, and Rudolf Arnheim, among others. One could find an essay on mathematics, such as the contribution by Stanislaw Ulam (who had worked on the Manhattan Project and was then designing thermo-nuclear weapons at the Los Alamos National Laboratory), in the same volume that presented composer John Cage's seminal article "Rhythm Etc."

The series appeared a decade after Kepes's revolutionary *New Landscape in Art and Science* (1956) changed the way art books were experienced and produced. Filled with stunning photographs of things that made a splash or a boom (or looked like they did) and featuring images that had previously been published only in scientific journals, his books were meant to be "looked at" rather than read. Kepes's innovative designs, which were delineating a new American avant-garde style, caught the eye of James Killian, president of the Massachusetts Institute of Technology and, later, the first presidential assistant for science and technology. Killian invited Kepes to MIT: if he could sell science with the same artistic flair with which he sold cardboard for the Container Corporation, one of his graphic design clients, then MIT's enrollment might benefit. Since World War II, science and engineering were struggling, as Killian recollected in 1969, associated "not so much with their socially constructive effects as with terrifying military technology and with the degradation of the environment." Killian believed that bringing together science and the humanities would be beneficial to both disciplines. He implemented this strategy to great success with Harold Edgerton's Strobe Alley lab, where students learned how to produce visually compelling images with technologies developed to analyze bombs and bullets. Engineering products could migrate from arsenals and factories to art museums, and back.

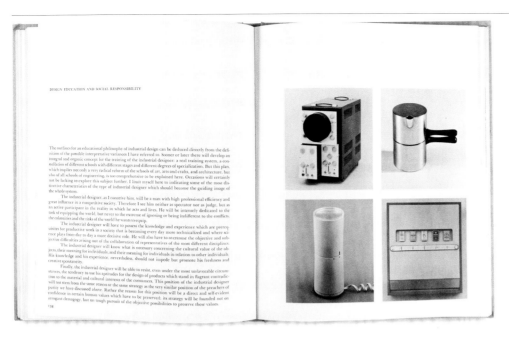

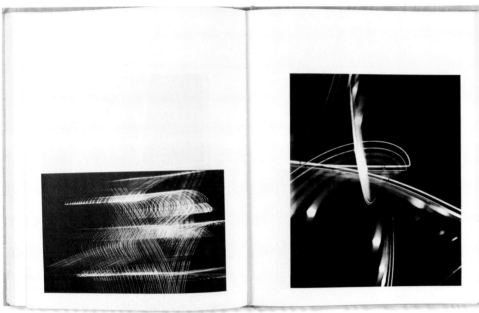

Spreads from *Education
of Vision* (New York:
George Braziller, 1965)

By the mid-1950s, Kepes had dropped the umlaut in *György* and abandoned his belief in physical space as fundamental to reality.

Kepes made a career out of reconciling science with art: at the Light Workshops of the Institute of Design in Chicago, he taught students to bend reality with slits, filters, prisms, and mirrors. His light modulators, used to produce cameraless photograms à la Man Ray, delivered an important lesson: light organizes space. Working with his mentor, László Moholy-Nagy (who had moved to Chicago in 1937), Kepes rejected traditional lens-based perspective images in favor of cut-ups, montage, and abstract geometric shapes. When the Art Institute of Chicago invited Kepes to display his design ads in 1943, he titled his first solo museum exhibition *Photographs without a Camera.*

Kepes found that Old World ideology for getting to the bottom of things (including Nazi blood-and-soil propaganda and Marxist materialism) could be easily dismissed in the New Continent. Spearheaded by Kepes and Moholy-Nagy, the "New Bauhaus" movement had a winning strategy: change the world by changing its appearance. By the mid-1950s, the Hungarian émigré had dropped the umlaut in *György* and abandoned his belief in physical space as a fundamental bedrock of reality. Why cling to things in themselves and long for the existence of a real-world independent of us when none could be found? At MIT, Kepes had plenty of support for his work: hired as professor of visual design in 1946, he founded the Center for Advanced Visual Studies in 1968, and remained there until he retired in 1974. The *Vision + Value* series served as a manifesto for this program.

Ultimately, Kepes's concept of interseeing revealed certain connections only by obscuring others: nowhere to be found in the *Vision + Value* series were explicit discussions about the movement's links to military and corporate interests. *New Landscape in Art and Science* had been sponsored by the defense industry (Ballistic Research, Aberdeen Proving Ground, Brookhaven National Laboratory, and the UC Radiation Laboratory, Armour Research, among others), Big Pharma (Abbott, Eli Lilly, etc.), and Big Industry (General Motors, U.S. Steel Corp., Standard Oil, etc.), and *Vision + Value* featured the work of some of their top researchers. By publishing images from scientific journals next to ones created by artists, Kepes taught us a new way to appreciate both. Images of nonlinear transformations, created by Los Alamos computers designed to simulate atomic explosions, looked just like Jackson Pollock paintings. With Kepes, it became impossible to see either as *just* art or just science. Side by side, they obtained a new meaning. Kepes sought to collect the "living fabric of the best knowledge of a given time" in beautifully illustrated books—that was all that mattered then. And today? Perhaps it is time to reconsider if the knowledge Kepes believed to be the "best" remains so for us.

Jimena Canales is the author of *The Physicist and the Philosopher: Einstein, Bergson, and the Debate That Changed Our Understanding of Time* (2015) and *A Tenth of a Second: A History* (2009).

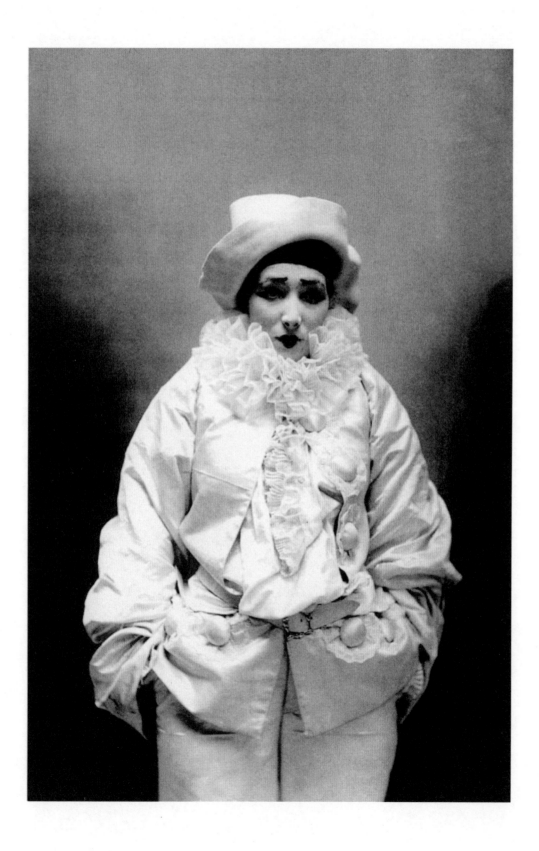

Posing, role-playing, or staging a tableau: the impulse to perform before the lens has been a fixture of photography from the beginning.

For the Camera

Simon Baker

From the first days of the first photographs, those taking the pictures and those being pictured were fully aware of the performative potential of the new enterprise. Consider the strangely stilted tableaux that William Henry Fox Talbot arranged on the grounds of his home, Lacock Abbey, in the 1840s: his friends and family posing as, well, friends and family, but nevertheless acting their own roles as best they could in bright sunlight under the cold eye of the camera. These, surely, were some of the first people ever to "pose" as themselves, as countless others have done for the camera ever since. But as well as performances aimed at the representation of some kind of natural life, there are also, in the earliest photographic experiments, something that we can recognize today as truly performative works.

Perhaps the earliest of these coincided with the 1839 advent of the medium: Hippolyte Bayard produced *Le Noyé* (Self-portrait as a drowned man) in October 1840. A direct positive print on paper (and therefore an easier and cheaper alternative to the metal daguerreotype), Bayard's self-portrait is not only a technical masterpiece but a conceptual one. It shows the inventor of the process, slumped as though sleeping, naked from the waist up, like Jacques-Louis David's 1793 painting of the assassinated Marat; Bayard's strangely dark hands a testament to both chemistry and hard work, crossed in peaceful resignation on his lap. But it is the title that completes the work, referring the viewer (whomever Bayard imagined that might have been) to the hopeless plight of the sitter: Bayard claimed to have invented photography before Daguerre, who received all the credit for the invention. In the photograph, he appears rejected, ignored, sinking without a trace below the high watermark of Daguerre's fame and fortune. Bayard's silent protest is probably the earliest, and certainly the greatest, of the first real performances made purely for the camera, and existing only as a photographic print.

There is, however, an umbilical cord of radical creativity linking this early moment in photographic history with all that followed, in which the self-portrait tends toward fantasy. Think,

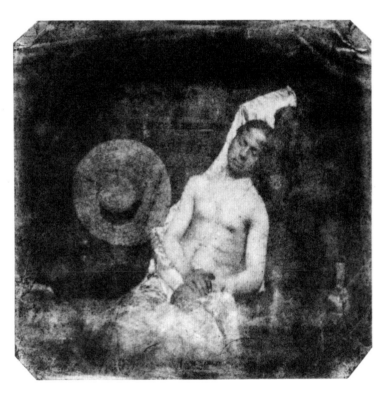

Hippolyte Bayard,
Le Noyé (Self-portrait
as a drowned man), 1840
© SFP

for example, of F. Holland Day's incredible serial self-portrait *The Seven Words* (1898), in which the artist presents himself not simply as martyred (like Bayard) but as Jesus Christ, crowned with thorns and enduring the agony of the crucifixion to illustrate the final words spoken from the cross. Part of a truly epic project to photograph the life of Christ in which Day took the title role (starving himself in order to do so), Day's *Seven Words* can be seen as both spiritual and blasphemous in equal measure. For although Day and his more enlightened critics, Edward Steichen included, saw this work, and indeed the project from which it was drawn, as a sacred enterprise, it was (and remains) a controversial photographic performance, decades ahead of the better-known role-playing conceptual practice that it appears to anticipate.

The ways in which the performative nature of photography and the photographic nature of performance are interrelated and intertwined will be the subject of an exhibition at Tate Modern in February 2016. This article, then, constitutes an initial attempt to walk (and blur) the line between the photography of performance and performative photography, circling around the question of when a photograph records a performance versus when a performance depends entirely on the photographic act, aiming not to present a hierarchy but instead to raise questions about the symbiosis at the heart of an apparent opposition that runs through the medium from its inception to the present day.

Consider performances at which a photographer happened to be present: there is much to be learned about the photographic potential in what only appears to be the subordinate role of the photographer. Harry Shunk and János Kender, or Shunk-Kender, as they are known, started out as photographers in the conventional sense (on the streets of Paris and Berlin) but then went on to become perhaps the most important official witnesses of a broad range of artistic practices, from Yves Klein's *Anthropometries* in 1950s Paris to the myriad performances of a generation of artists working in New York in the '60s and '70s. There are many examples of the straightforward documentation of performances by figures like Eleanor Antin, Yayoi Kusama, and Marta Minujín (to name just three) but also more complex situations in which Shunk-Kender either become active participants in the events, eliciting poses or demonstrative acts, or even making the works themselves, as is the case with Klein's 1960 *Leap into the Void*, which was collaged together from two negatives to produce the artist's legendary (and illusory) dive off the side of a house (see page 43). Elsewhere there are dramatically posed portraits, like those showing the artist Niki de Saint Phalle in 1961, gun in hand, both facing the lens and in profile, but not actually, as it happens, making one of her *Feu à Volonté* (Shot canvases), which resulted from that particular performative process.

More fascinating still are those moments in Shunk-Kender's work when they begin with a "document" of an act (a live performance by Yves Klein or Merce Cunningham), then transpose this material, in the darkroom, into something else entirely. Such photographs have a relationship to performance that is like that of an amplified echo to an original sound: related, for sure, but absolutely distinct and different in tone and resonance. In one of the most dramatic examples of their practice, Shunk-Kender solarized the forms of Cunningham's dancers (performing *Nocturnes* in Paris in 1964) almost to the point of abstraction, until the precisely choreographed figures from a real performance became merely glowing bodies of light; entangled, entwined, and yet perfectly balanced as photographic compositions.

Beyond the history of photographing performances as such, the relationship among these terms is transformed by a shift along the scale from photographers making photographs

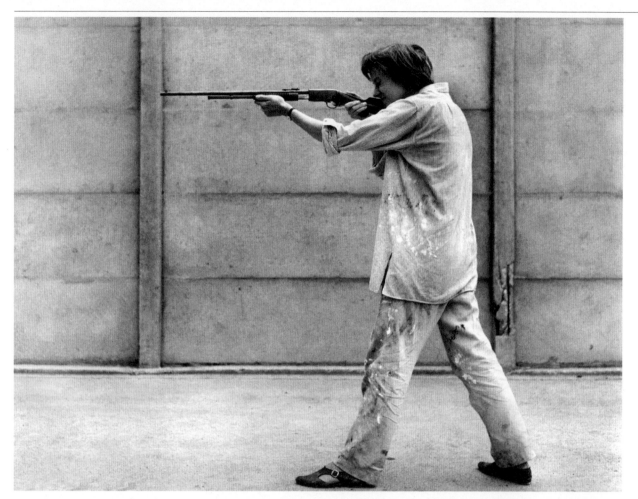

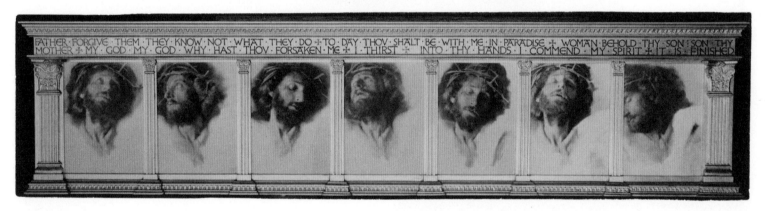

F. Holland Day,
The Seven Words, 1898
© The Metropolitan
Museum of Art and courtesy
Art Resource, New York

**Such photographs have a
relationship to performance
that is like that of an amplified
echo to an original sound:
related, for sure, but absolutely
distinct and different in tone
and resonance.**

of performances to performers making work for, and with, photographers. Once again, it is possible to trace this kind of practice to the early years of photography: think for example of the stunning series of images of the mime Charles Deburau, whose Pierrot found himself not in the theater, nor even on the street, but instead acting out the range of his expressions—"surprise," "laughter," "pleading," and so on—for the camera of Adrien Tournachon, brother and, briefly, business partner of French practitioner Nadar, perhaps the greatest studio photographer of the mid-nineteenth century. Bringing the actor into the studio, for a performance that was only ever destined to result in a photograph but existed nevertheless in direct relation to a series of performances "off-camera" (in the career of the subject), ushered in one of the richest and most consistent seams of gold in the Nadar story. For, from the 1850s to the studio's end under Nadar's son Paul in the early twentieth century, a stellar array of Parisian actors and actresses, Sarah Bernhardt being the most celebrated and frequently photographed, would be called upon to reconstitute their roles (with costumes, sets, and cast) for just a few moments before an audience of one lens in the Nadar atelier.

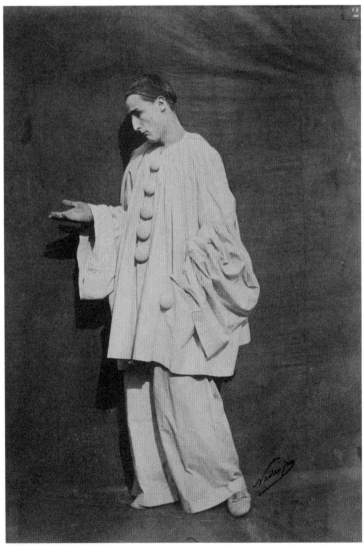

While Nadar's move was to transpose a performed scene from the theater to the more precisely lit tranquillity of his studio, elsewhere the drama (and the collaboration) shifts in the other direction. Perhaps the most important and truly collaborative photographic performances of the twentieth century are those made by and with Eikoh Hosoe in Japan in the late '60s and early '70s. Indeed Hosoe's masterpiece, the 1969 photobook *Kamaitachi,* is one of the few examples of the genre (or indeed any similar art form) in which both the photographer and the subject are equally credited: "Photographs: Eikoh Hosoe, Performance: Tatsumi Hijikata." In *Kamaitachi,* Hijikata, the founder of the butoh dance movement, takes his act into the open spaces of rural Japan in an epic series of set pieces captured as a sequence of single images by Hosoe. Less known, but equally important, is a similar collaboration with the actor Simon Yotsuya. Made in 1971 but never shown until the publication of the book *Simmon: A Private Landscape* in 2012, this key Hosoe work, like *Kamaitachi,* is an example of an almost unique hybrid form. The story is acted and posed by Yotsuya across the limits of fact and fiction, opening with an image in which the actor is shown applying his makeup in the shadow of a train station. This set piece inaugurates a whole gamut of games, dramatic poses, and physical expressions of emotion by Yotsuya, which are transformed by his collaboration with Hosoe through the double logic of the photographic series and sequence. As such, Yotsuya is able to offer something impossible on the stage, a cumulative performance, each image working with those that precede and follow it like the storyboard for a film, albeit each "frame" having been perfectly composed through the restrained poetry of Hosoe's pictorial approach. Hosoe is probably unique in this level of evenhanded collaboration, the result of an obsession with dance and theater coupled with his unique sensitivity to the fact that photography is essentially always a performative act.

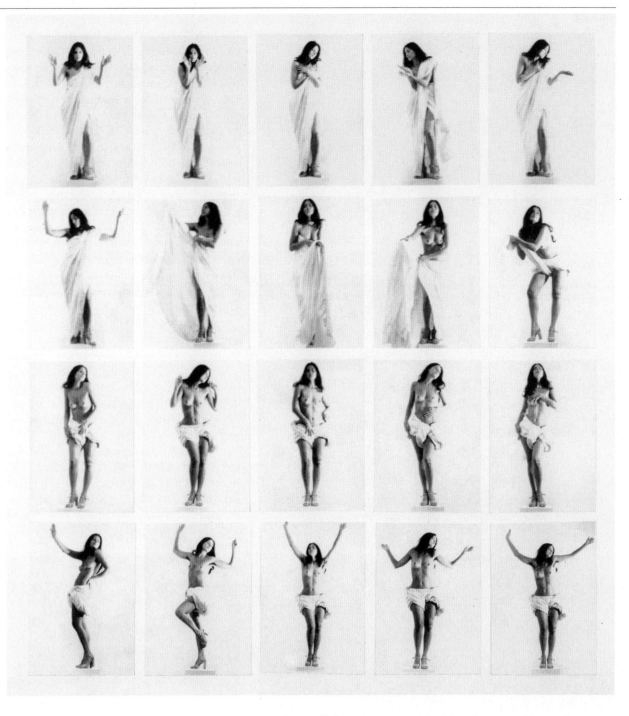

Nadar's move was to transpose a performed scene from the theater to the more precisely lit tranquillity of his studio.

The collaborative potential of the photographic performance is evident too in the work of contemporary artists like Erwin Wurm, whose *One Minute Sculptures* are both "produced" as finished works and at the same time seem to encourage viewers to "try this at home," or at least in the gallery. Wurm's playful repurposing of objects like buckets, biro pens, and fruit transforms them into ludic bodily adornments and pointless physical supports: a figure parallel with the floor, balanced on a carefully arranged group of oranges. But far from the complex and often dangerous experiments of suburban home-sculptors—in which category we might find upstate New York–based artist Les Krims setting fire to things or arranging nude models in awkward positions in the 1970s—Wurm instead proposes poses that are more often uncomfortable rather than implausible or improper, playing games not only with his subjects (who have included, surprisingly, the model Claudia Schiffer) but with notions of conventional decorum associated with posing for the camera.

Two other photographic works that engage notions of performativity and propriety, albeit in very different ways, are contrasting uses of the strip by artists Hannah Wilke and

Below left:
Jemima Stehli,
*Strip No. 5 Dealer
(shot 2 of 6)*, 1999
Courtesy the artist

Below right:
Erwin Wurm, *Untitled
(Claudia Schiffer)*, 2009
Courtesy Galerie Thaddaeus
Ropac

Jemima Stehli. Wilke's classic 1976 film performance *Through the Large Glass* sees the artist stripping slowly and deliberately in a series of freeze-frame poses behind (and through) Marcel Duchamp's seminal transparent sculpture, but in fact it is just one of a number of calculated strips that began with a live performance in November 1974. A second version of the same work from the same year, produced specifically "for the camera" as a sequence of photographs and titled *Super-t-Art*, shows the progress of Wilke's single prop/garment, a white sheet, from an initial toga-like shift through a series of symbolic revisions (simultaneously a form of strip) that concludes with a biblical wrap and pose directly referencing Christ on the cross. Stehli, a British artist who came to prominence in the 1990s, assumed a stance similar to Wilke's, taking a counterposition to the dominant language and forms of feminist practice and the associated articulations of the desiring male gaze; she produced her own *Strip* series (1999–2000), this time with the complicity of a select group of male viewers. Stehli's strips (also sequential photographs) show curators, writers, and critics from the London art world in the act of taking self-portraits—using the artist's camera in a neutral studio setting—while Stehli strips with her back to the camera but facing her male "sitters." The results are uncomfortable and comedic, with the artist's performance being both the reason for the photograph (in terms of her own self-image-based practice) and an obstacle to the person nominally in control of the process of simultaneously picturing themselves.

The critical language of the performative self-portrait is so broad and, at this point, so familiar as to be almost impossible to summarize, but there are still some important and often overlooked contributions to the field, especially in terms of the politics of identity, from key historic works like Linder's *She/She* (1981), Adrian Piper's *Food for the Spirit* (1971), or any

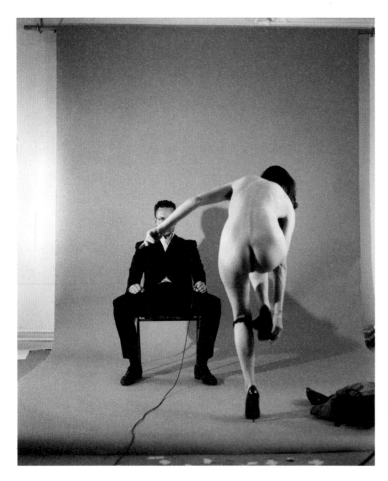

The critical language of the performative self-portrait is so broad and, at this point, so familiar as to be almost impossible to summarize.

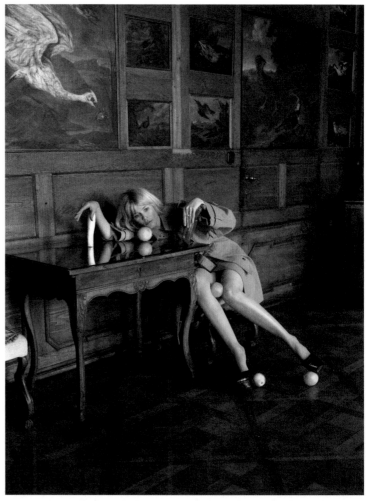

Masahisa Fukase,
from the series
Bukubuku, 1991
© Masahisa Fukase Archives

of Hans Eijkelboom's works of the early '70s to recent projects like Samuel Fosso's *African Spirits* (2008) and Tomoko Sawada's *ID* series (1998–2001). But beneath the more readily visible ongoing practice of interrogative self-portraiture there remains the submarine terrain first explored by Bayard in 1840. Interest in this, too, can be traced in contemporary work, most notably Masahisa Fukase's incredible 1991 project *Bukubuku* (although it should be said that Fukase is more waving than drowning). Named for the Japanese onomatopoeia for the sound of bubbles, *Bukubuku* is a series of seventy-nine self-portraits the artist made entirely in his bathtub: clothed, naked, smoking, spouting, sinking, fractured by the symmetry of the waterline. Fukase's work is both a playful virtuoso gesture (working with the lens at its limit) and a deeply personal work exploring isolation and loneliness, a strange merman's pendant to his better-known study of depression, the 1992 book *The Solitude of Ravens*. Fukase spent much of the early part of his career photographically documenting the life and activities of his immediate family, with extended bodies of work like *Yohko* (1978) and *The Family* (1991). But with *Bukubuku*, he ends up turning the camera back on himself, only to shy away from a searching self-examination via the self-portrait in favor of an extended game of smoke and mirrors. Fukase, then, at the end of the twentieth century, leaves us pretty much exactly where we found Bayard early in the nineteenth: wondering at the expressive potential of the camera in the hands of someone willing to perform for it.

Simon Baker is Senior Curator, International Art (Photography), Tate, London. The upcoming exhibition *Performing for the Camera* will be on view at Tate Modern February 18–June 12, 2016.

Self-Portraiture in the First-Person Age

Lauren Cornell

All users perform a version of themselves on Instagram. But how are artists today using the commercial platform to calculated effect? New Museum curator Lauren Cornell looks at how some artists deploy strategies of role-play, humor, withdrawal—or relish in the messiness of everyday life—to unravel social media's conventions of self-presentation.

K8 Hardy's video *Outfitumentary* (2001–11/2015) is a montage of hundreds of self-portraits shot over the course of a decade in whatever location the Brooklyn-based artist happened to be living or working at the time. In one early scene, alone in her bedroom, she positions her video camera for a wide-angle shot, then leaps onto a chair and, standing in profile with one leg hoisted onto its back, gazes at the camera with a mix of ferocity and knowing wit. Dressed in a black-and-white checked miniskirt and red thrift-store tee with the sleeves ripped off, her hair in a flowy mullet, her look is a combination of DIY punk, '90s indie, and femme lesbian, plus a dash of Texan dude.

When I saw *Outfitumentary* in 2015, it hit a nerve. Hardy's self-portraits are, in their rawness, vulnerability, and trial-and-error fashioning, very different from today's selfie culture. The key difference is one of audience: in a 2015 *Artforum* interview, Hardy said she took the portraits *only for herself* without caring who might see them. "Only for me" now seems an outmoded or rare sentiment in a culture in which personal archives accumulate in public, not in bedrooms or on dusty hard drives. Her vignettes don't only offer a glimpse of her life and milieu, they reflect an intimate approach to self-portraiture that has yielded to a pop culture that compels us to narrate our lives in the first person. When we take photographs today, we always care about who, besides us, might see them.

Now that we are at the end of the *only for me* era, what strategies of artistic self-portraiture are viable? How to distinguish art from selfies in the *big scroll*? Instagram, for example, is a buffet of genres: documentary, appropriation, political commentary, role-playing. But its inherent immediacy, sociality, and instant commodification (every stroke from liking to tagging creates community for *us* just as it creates value for Instagram) changes the nature of these gestures. Here, humor, mundanity, and abjection play against more rule-abiding images, even as the rules for a *winning image* continually evolve. For instance, polished selfies give way to the casual, and meta-commentary now supersedes "genuine" expression. Amid this push and pull—images in lockstep with Instagram's optimized-for-advertisers creativity competing with those who critique such blatant consumerism—what does it look like to carve out a space for abstraction, dissonance, and transgression: in other words, for art? Several artists today are offering answers to this question.

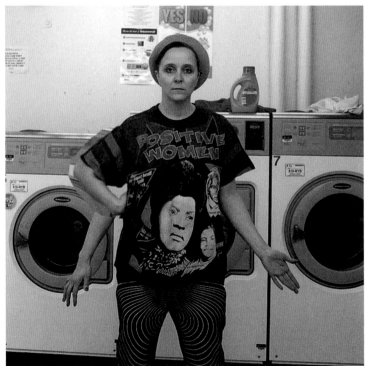

 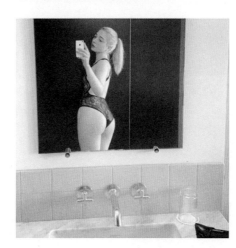

Amalia Ulman,
Excellences and Perfections,
2014
Courtesy the artist

What does it look like to carve out a space on Instagram for abstraction, dissonance, and transgression: in other words, for art?

"TMI is the best way to enjoy some privacy," predicted artist Amalia Ulman of life in 2020 in a text published within the online journal *e-flux*'s *supercommunity* series in 2015. "Posting confusing information, over-posting, over-sharing, and over-tagging are used as strategies for diverting attention." Ulman's TMI (too much information) approach seems like a sound strategy and also happens to describe her performance and visual art, which often involves excessive self-exposure where the originary self is deeply in question. In *Excellences and Perfections* (2014), for instance, she stages an *Extreme Makeover*–style transformation—allegedly involving facial surgery, breast augmentation, dieting, and pole-dancing classes—and documents each step.

When I first saw this work, I thought of feminist artists who were active in the '70s, like Orlan, who underwent physical transformation for her art, or Hannah Wilke, who documented her body after being diagnosed with breast cancer, and I couldn't see how Ulman's work transcended that of her predecessors. But I came to understand it as a *site-specific* intervention, one born out of the mores of self-creation and consumption on Instagram. *Excellences and Perfections* amplifies the coercive prompts that inform photography here; these prompts are wildly contradictory and include being beautiful, being real about pain, exposing every detail of one's life to the public, and retaining a sense of mystery. Of course, this mode of calculated, mediated self-presentation is not heretofore unknown. But when Rosalind Krauss described "the aesthetics of narcissism" associated with video art in a 1976 essay for *October* journal, it would have been hard to predict the mass habitation of narcissism we know today—a state Ulman's work consciously emerges from. Another aspect of *site specificity* is how her work is constituted not just by photographs but by an ongoing call and response. Like so many projects on social media, it only signifies as art

Top:
Xavier Cha, <3 Like:
A BOFFO Instagram
Project, 2014
Courtesy the artist and
BOFFO NY

Bottom:
Juliana Huxtable,
Untitled (Instagram Photo),
2015
© and courtesy the artist

when seen as a dialogical series—or, more aptly put, a feed that includes comments, tags, and likes. Here, the self is nothing without its followers. And, in this case, it's unclear how Ulman's audience sees her: it's likely some of her followers see the work as performance while others see it as the true story of a relatable blonde in search of the perfect "after" shot to the extreme makeover process.

A counterstrategy to TMI is total retreat. In an interview published in *DIS Magazine* in 2015, choreographer and visual artist Xavier Cha wrote, "I personally don't feel a need at the moment to add to the excessive inundation; that's why I'm more inclined to create experiences and open up ways of thinking rather than add to the clutter of objects and images. To me, most of that has grown mute." For Instagram, Cha conceived of a project consisting of seventeen sound files each comprising an individual post. Their visual aspect is minimal, featuring only a play button and clip timeline, but the texts are dense: each one is a captivating performance in which a hired actor reads a pornographic or violent passage, her voice stripped of any inflection or emphasis. The quick sound bites evince states of desire, rage, and psychological intensity rarely found on Instagram. The script of one audio piece reads, "A beautiful young man's face, cradled by a hand, grasping his scalp, his mouth longingly agape for one of the hard cocks, coming on his face, from every angle of the frame."

Cha has long been interested in how the self forms in relation to technology. Previous performances include *Ring* (2010) in which a throng of photographers, with cameras rapidly, loudly flashing, snake around a gallery with no incentive, i.e., no notable person or event in sight. Or *Body Drama* (2011), in which a performer writhes on the floor as a video camera, strapped tightly to his or her body, records the performer's facial expressions, which are projected live and large onto a nearby screen. In her new work, Cha displaces herself to represent what is unrepresentable—or off-limits—on Instagram. If these were images, they would be rapidly censored. As sound, they escape the trawling bots that would deem them pornographic and delete them. They offer a counterpoint to the "excessive inundation" of visual imagery in social media that, in her opinion, becomes neutered and voiceless. The work points to how sound and language open up a territory where codes of conduct are nascent if at all existent, and 1:1 representation is irrelevant. Her retreat, or visual erasure, also dovetails with an artistic conversation related to feeling under threat—artistically or personally—by a relentless 360-degree gaze peering out from multiple devices (see the work of Zach Blas or Adam Harvey, artists who are interested in privacy issues and so-called digital dark spaces). Withdrawal of the body and substitution of the voice in Cha's work emerges as a potent form of self-protection from Instagram, and other commercial entities, that are continually tracking our interests and quantifying our movements to better advertise to us, or sell our data to another source. Without a body, she is untraceable.

Self-portraiture in the arts has long been linked to political questions of visibility and representation. Artists associated with identity politics of the late '80s and '90s contested the essentialist discourse of multiculturalism that would have them reduced to narrow social categories with attendant stereotypes. In a sense, artists emerging today have similar battles to wage—presenting themselves as more complex than their social appearances— but these battles are now often staged within highly branded and commercial spaces of social media that harden old pressures and add challenges. Faced with the vicissitudes of self-branding, artists often respond or resist with depictions of highly flexible, liminal selves. Photographer Cindy Sherman, who since the '70s

Withdrawal emerges as a potent form of self-protection from Instagram and other entities.

has seamlessly inhabited various female archetypes, drawn from Hollywood films or mass culture, is frequently invoked as an important precedent to this younger generation of women artists, such as Hardy. But a more suitable precursor might be Claude Cahun, the early twentieth-century Surrealist, whose pliable self-portraits released her from strict gender types and evoked the vast inconclusiveness of her subjectivity.

Cahun was also an expert of collage, of the cuts and edits now associated with digital editing programs. Her spirit hovers over several of the most poignant self-portraitists on Instagram, all of whom use editing tools—cropping, filtering, highlighting—techniques that weren't available so freely only a decade ago (one

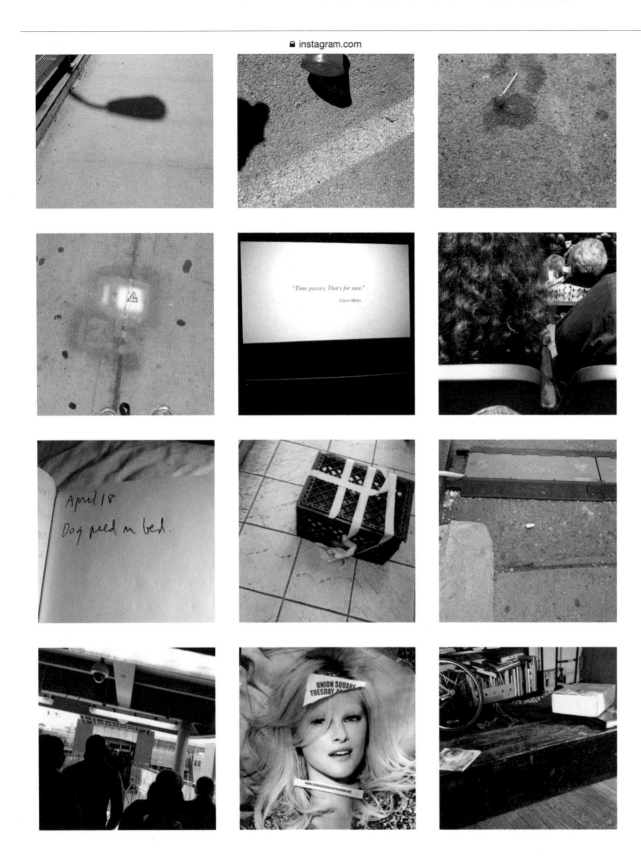

**Screenshot of Eileen
Myles's Instagram feed,
April–May 2015**
© the artist

used to have to buy and master Photoshop, whereas Instagram
simplifies basic special effects). These include the searing poet
and artist Juliana Huxtable, whose photographs project her
into fantasy realms in which she channels divergent cultural eras
and their attendant fashions, from the 1960s and '70s Black Power
movement to the 1990s stylization of black militancy in hip-hop
as seen through camouflage clothes. The performance artist
boychild's performances take on the hard and heavy feel of a
club, with immersive lighting—pink, green, or black, all shot
through with white light—and remixed pop songs, for instance
a guttural version of Destiny Child's airy track "Say My Name."
Center stage, boychild mixes futuristic, sci-fi effects—her mouth
and hands glow as she dances—with the simmering vengeance

and wild energies of what one imagines a recently hatched posthuman might feel. Her performances often seem to be rehearsed or tested out on Instagram, where her feed is rife with images that look otherworldly: she shimmers holographically, submerges herself in color fields, and appears splattered in red paint that looks like blood from an unknown source. These images punch out of traditional gender binaries with a new set of terms; boychild seems to invent new gender options that blend heretofore unpaired modes from gladiatorial warrior to ethereal hologram. In their constant mutability and careful composition, they eschew rawness and, instead, become self-fashioned icons: half self, half shareable possibility.

Hardy, too, has been posting self-portraits to Instagram since 2013 that she refers to as "sketches," a fitting term for the open-ended response such an iterative medium elicits. In her stream, she can be seen in myriad "looks," as imaginative and disparate as those in her video *Outfitumentary*, except here increasingly with body parts cut, collaged, or resized. In one, she appears against the side of a whitewashed house with stylishly contrasting clothes, flowered top, yellow jacket, faded neon airbrushed skirt, prompting a lone comment from artist Travis Boyer (@fazboy) reading "beauty." In others, she dives into the abject, surreal, and humorous: she collages her facial features—hairline, eyes, lips—so that they hover over a patch of dirt; pastes a miniature version of her body onto a dining room table, as if she is a living centerpiece; doubles and distends herself; layers her naked backside onto someone else's torso with a comment reading "a piece of burger from yesterday"; and cycles herself through a striking range of poses and attitudes, special effects–assisted and not. Looking at her feed, one gets a kaleidoscopic impression of a persona—her own—that clearly refuses to be flattened into a recognizable Insta-brand. Hardy, Huxtable, and boychild transgress Instagram's norms: in their expansive, irreducible self-presentations, they veer away from the hardened rule-playing privileged personae that Ulman's work undermines.

In contrast, the lack of effects and the absence of staging—the lack of a curated, stylized self—whenever found, has its own allure. The American poet Eileen Myles's feed, for instance, often seems fired off or pounded out, similar to the feel of her rousing, blunt verse. Here are sinks of dirty dishes, jokes typed in Microsoft Word docs, a semi-sucked red lollipop lying on a dirty street, a two-line diary entry: "April 18 / Dog peed in bed," a string of shots of a single melting candle, the first explained in the comments with her note "& I'm hearing a train." Showing multiple versions of the same shot reveals the entire photography process, not just the "good" one that made the cut. Her photographs are sometimes taken at off-kilter angles, almost as though they were taken from the perspective of objects rather than people—a shirt button, a moving car, a chair. In one particularly abstract and compelling series, she takes multiple shots of several scavenged woodchips. The meaning or significance of the woodchips is unclear to the viewer—at first, they appear like souvenirs of a walk in the woods or mismatched puzzle pieces—but Myles's interest in them is writ large through her continual posting. As the images accumulate and the woodchips find themselves persistently rethought and rearranged, they take on an anthropomorphic quality, as if they are helpless models stolen from their organic habitat and forced to submit to the arbitrariness and scrutiny of a modern device. In the most recent shot, perhaps the series finale, they are mingled on a plate with garlic and crackers, as if their allure has been fully exhausted. Myles's feed is full of upstart, rowdy sketches that diverge from the carefully composed pictures of pretty people and lattes for which Instagram is often (and justly) parodied. They give no heed to the inherent rules of the medium but rather create space for the messiness of life, and of the creative process, that Instagram users often crop out.

What it means to present yourself, your body, your autobiography, your day-to-day existence in public has changed today, as the first person has become a default and commercialized mode of presentation. What if apps compelled us to speak collectively, with our biological family, or through consensus with a group of diverse peers, or around shared causes or values? We would be challenged to balance conflicting opinions, to gather consensus and break away from self-interest. Instead, pop culture has hardened around the individual voice. In this context, strategies for presenting and preserving a singular artistic viewpoint are harder to grasp and hold, especially because social media is so adept at absorbing its antagonisms. The appropriation of subcultures (by brands or popular usage) has never been faster or more efficient. What feels dissonant today, erasure, say, or disorder or reinvention, as named above, may, in only a short time, become status quo. But social media, in its omnipresence and ubiquitous use, has become a main site for the contestation of identity and the self—a new arena that repeats and extends previous eras' questions of visibility and self-definition, and begs for artistic challenge.

Lauren Cornell is Curator and Associate Director, Technology Initiatives at the New Museum.

Performances are ephemeral; photographs are permanent. When is an image more than a mere document? How do images bring us closer to an event we never witnessed?

On Record

RoseLee Goldberg and Roxana Marcoci
in Conversation

Roxana Marcoci: **RoseLee, you pioneered the study of performance art with a landmark book, *Performance Art: From Futurism to the Present* (1979), and recently expanded it with an account of the technological, political, and aesthetic shifts in performance art that have occurred since the turn of the new millennium. What do you think the advent of photography did for performance? And why have photography and performance been so intricately linked? From its beginnings, photography has had a unique relationship to performance, which explains why we can chart a history of modern and contemporary performance art, while it's more difficult to do so for premodern times.**

RoseLee Goldberg: A fascinating place to begin, "the advent of photography." Before the photograph, a painting or drawing would have captured the performances taking place in the studio or workshop—sometimes even those staged with an audience present, but more often done without a public. We need to activate our imagination to conjure the models and backdrops used to make so many of the great history and narrative paintings from the past. Performance since the 1960s became associated

with the word *documentation*, as though the photograph was simply a record of an act, an afterthought, to capture an ephemeral event. But as we know from images of works by Yves Klein, Joseph Beuys, Yoko Ono, Carolee Schneemann, or Chris Burden, and so many artists of the 1950s, '60s, and '70s, photographs of performances were often consciously staged for the camera, allowing them to become iconic and powerful images that would live on into the future.

RM: **Gina Pane, a pioneer of performance art, from the start collaboratively worked with one photographer, Françoise Masson. In discussions with Masson, she prestaged the shots that the photographer then took during the live performance. Pane made the final selection of pictures and composed them into montages that she called *constants d'action* (proofs of action). Photography, beginning in the 1960s, signaled a critical change in its relationship to the discourses of performance, sculpture, writing, and film, as artists who did not consider themselves photographers in the conventional sense began to use the camera for projects that were not specifically photographic. This moment also coincided with the advent of Conceptual art.**

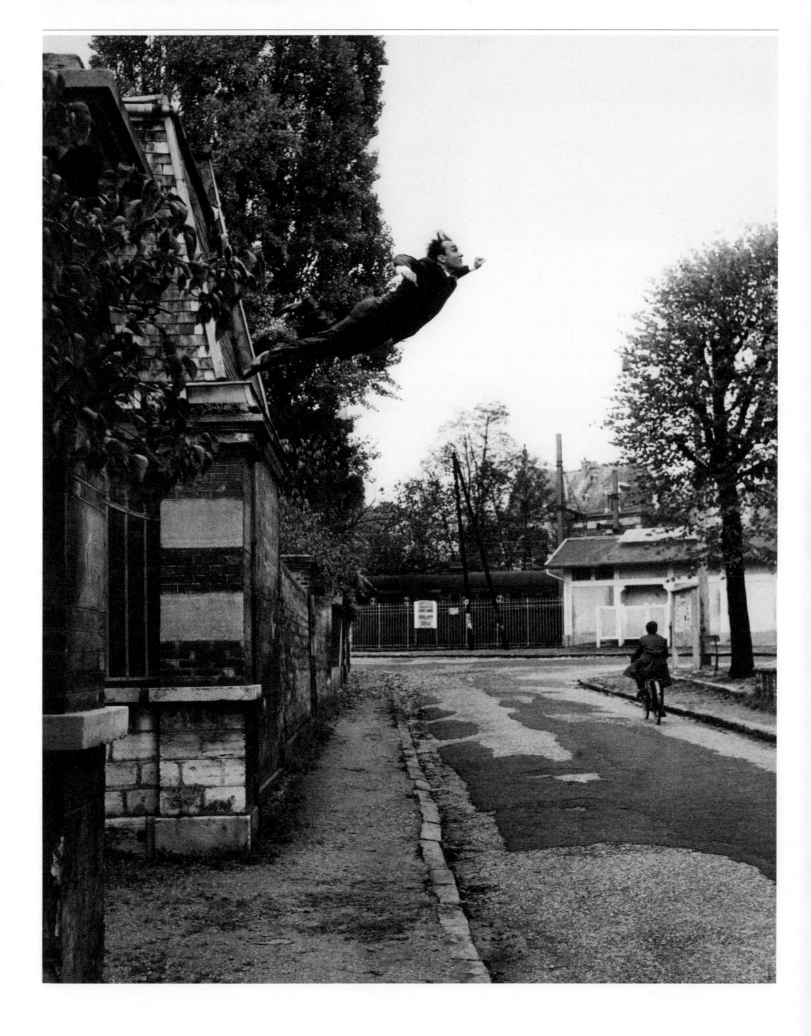

RLG: The anti-aesthetic of Conceptual art and performance, so-called documentation consisting mostly of black-and-white photographs drained of spectacle or framing, or carefully monitored lighting, was the beginning of the break—the separation of what we consider photography in its historical and conventional sense, and the photograph as created by visual artists of the 1970s and '80s. Over the past fifty or so years there has been an incredibly rich history of performances made with the intention of being captured by the camera, or vice versa, photographs made of unforgettable performances, as you made so clear in your important 2011 exhibition, *Staging Action: Performance in Photography since 1960*, at the Museum of Modern Art.

Roxana, as a curator and historian looking at photography in so many forms, what do you think distinguishes photographs of performance by visual artists? To me, it seems that no photographer could possibly come up with an image such as Marina Abramović's *Balkan Baroque* (1997), of her scrubbing 1,500 cow bones, wearing a white tunic that becomes gradually bloodied over time. It represents the horrors of ethnic cleansing in a way that is particular to a visual artist. A photojournalist or photographer might make the image far too literal; it would have none of its poetry. There is a formality to Marina's photograph—and a visual imagination at work in interpreting its content—that would simply not come from a *photographer*. For me, photographs of performances reinforce that these performances are the work of *visual artists*. Consciously or not, the artist understands the visual impact of her performance, so no matter who is photographing the work, whether staged or captured live, by the artist or by an independent photographer, the content, the image that emerges from the performance, could only come from this genre we call artists' performance.

RM: The premise of *Staging Action: Performance in Photography since 1960*, and prior to it the section that focused on "The Performing Body as Sculptural Object" in the exhibition *The Original Copy: Photography of Sculpture, 1839 to Today*, which I curated at MoMA in 2010, was that photography plays a constitutive rather than merely documentary role when performance is staged expressly for the camera. The photograph of an event *constitutes* the performance as such. Artists working in front of and behind the camera—Bas Jan Ader, Eleanor Antin, Chris Burden, VALIE EXPORT, Gilbert & George, Yves Klein, Lynn Hershman Leeson, Ana Mendieta, Bruce Nauman, and Lorna Simpson—have engaged the "rhetoric of the pose," a pose enacted for and mediated through the camera lens. Especially in the radicalized climate of the 1970s, when women's liberation took center stage, artists such as Hannah Wilke reconfigured their bodies in the spirit of activism to comment on the power structure of gender difference. And they used performance and the camera to engender it. To make what she called "performalist self-portraits," such as *S.O.S. - Starification Object Series* (1974–82), Wilke hired a commercial photographer to take pictures of her posed like a fashion mannequin in various states of undress, sporting here an Arab headdress, there sunglasses and a cowboy hat, there curlers in her hair. She also "scarred" her naked flesh with a swarm of labia-shaped chewing-gum pieces. Wilke's pose as a stigmatized star in *S.O.S.* underscores the key role of the camera in the intersection of performance and photography. My question, then, is whether there is such a thing as unmediated performance.

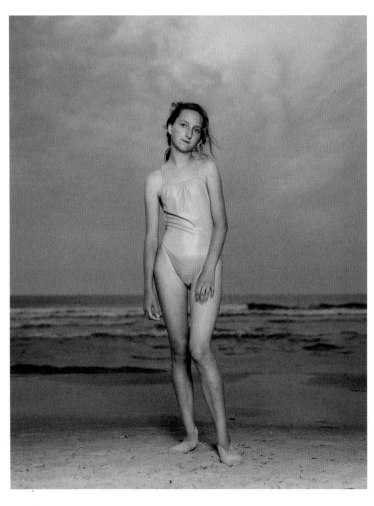

RLG: Depends on how strictly you define *mediated*. As already mentioned, painting and drawing before the twentieth century, as well as text, word of mouth, are all forms of mediation.

RM: What would you say, then, about the work of Tino Sehgal, who insistently resists any kind of documentation of his time-based work?

RLG: Indeed, I cannot think of any performance today that is unmediated or not photographed, except for the work of Tino Sehgal, who, as you point out, has emphatically resisted documentation. Yet his position is as much a formal proposition as one of denial, which suggests that his concepts are more fully absorbed by those who watch and listen, and who are not distracted from their engagement with the performance by a camera or an iPhone in hand. In some ways, his refusal to allow photography works in favor of such submission to the work itself. It also forces writers to examine the work quite differently, filling in for the missing images. It's important to remember that Tino's starting point is dance—the transference of ideas, of body shapes, content that moves along a different trajectory, in muscle memory—and I believe he's asking us to give his work that level of visceral and intellectual concentration.

RM: A year ago I organized a forum on contemporary photography at MoMA around the *Pier 18* exhibition organized in 1971 by independent curator, activist, and publisher Willoughby Sharp. Sharp commissioned twenty-seven artists—all male, ranging from Acconci to Lawrence Weiner—to engage in performative actions on the pier. Realizing that the derelict structure could not accommodate an audience, Sharp envisioned the end result of the commission as a museum presentation, giving the photographic duo Harry Shunk and János Kender, who documented the performances, an integral role. *Pier 18* foregrounds the degree to which photography actively contributed to the conceptual makeup of performance art in the 1970s. I invited Barbara Clausen, who teaches performance theory and history at the University of Québec, to be one of the guest speakers at this forum. She argued that what we perceive as "live" performance is always subject to mediation, since each performance is already built on the relationship between mediated and so-called authentic identities. Consider *TV Bra for Living Sculpture* (1969) or *Concerto for TV Cello and Videotapes* (1971), for instance, in which experimental cellist and performer Charlotte Moorman integrates live with mediated elements in performing Nam June Paik's scores. I think she has a point. How do you see the photograph mediating the experience of the viewer?

RLG: The photograph for me is like picking up a shard of pottery in Pompeii and finding the story of an entire civilization in a handful of material. The photographer is the first tier of the history of performance, the first line of record, and we need to learn how to read the photograph—as good art historians or archaeologists do—for its iconography, for its clues about the times, the politics, the communities in which the work took place, where it occurred: Were people seated on the floor or standing? Does this photographer give us a sense of audience, or not? The more we study the photographs of a performance from the past, the more details are revealed. Photographs give us back our experience of life. We see our own histories through childhood photographs and think that we actually remember the moment even if we were too young at the time to have

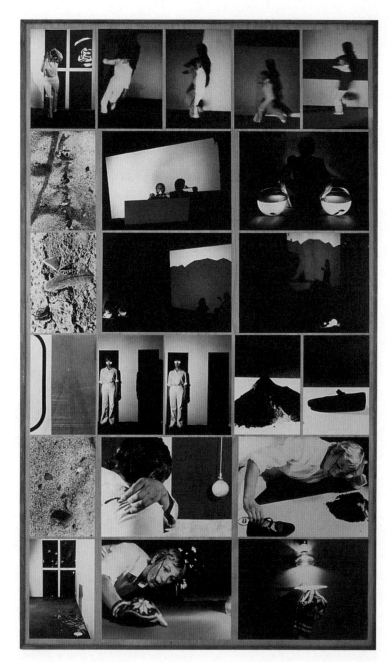

Gina Pane, *Little Journey*, 1978. Photographs by Françoise Masson
Collection Frac Bretagne / © ADAGP, Paris 2015

The photograph for me is like picking up a shard of pottery in Pompeii and finding the story of an entire civilization in a handful of material.

I am not one to say, "You had to be there." I wasn't at the Battle of Waterloo either. And indeed, this applies to knowledge in all its forms.

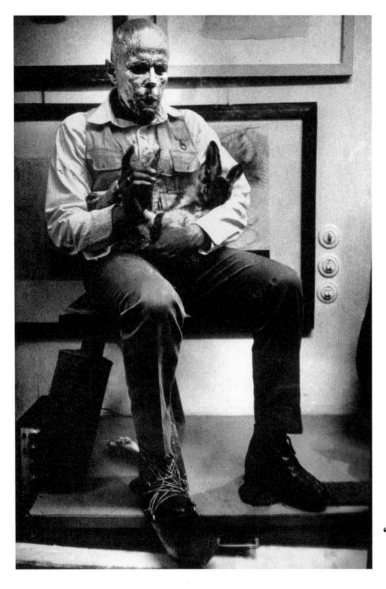

registered the memory. So, yes, I think photographs have an extraordinary capacity to bring us closer to the work, to give us an experience of the work, and to allow us to build a reference bank of images and ideas as we move on to the next performance, whether witnessed live or not. They make our understanding of the world and of the values and sensibilities of the artists making this work more layered, more sophisticated, more complicated.

RM: **In what ways has live performance changed our perception of the still image? I can think, as mentioned, of the many ways in which artists have performed exclusively for the camera lens, or staged tableaux, film stills, and photo-sequences. But I am curious as to what you would consider to be the performative in photography and the photographic in performance.**

RLG: The two have had enormous impact on each other. For me, the work of many artists whose practices we might discuss under "photography" also shows the influence of live performance of the 1970s and '80s in the composition, color, and physicality of their frequently life-size photographs. The work of Rineke Dijkstra, for example—with its centrally placed, fully frontal figures that dominate almost the entire surface of her large photographs—is very much influenced by performance. Steve McQueen's early photographs and short films, similarly focused on the singular figure or figures on a large ground, make me think of the history of performance in photography, from Klein to Vito Acconci or Adrian Piper. The influence of classic photography on performance might have less impact, because I don't believe that too many of the artists whom we think of as making performances look closely at the history of photography as a reference for the kind of images that they made, although they were certainly very aware of an aesthetic of photography by visual artists such as Ed Ruscha, John Baldessari, or Andy Warhol. That being said, quite a few younger artists with whom we have worked, such as Jesper Just, Liz Magic Laser, or Ryan McNamara, started out in photography, which says something about the nature of their image making and its potential for performance as well as about the way our views of photography have changed over the past two decades. But may I turn the question over to you, as one coming from "the other side," i.e., photography?

RM: **I would say, in fact, that the performative address of Dada, Fluxus, Happenings, Actionism, and recent participatory art all rely conspicuously on the photographic aesthetic and its apparatus. Regarding the photographic in performance, it's an area that needs further investigation, but I think of film stills, for instance, in Cindy Sherman's appropriation of poses from fictitious pictures when performing her scenarios for the camera; the same could be said of some of Stan Douglas's staged photographs in which he takes on the role of a photographer from the 1950s or '70s—or Andy Warhol's screen tests where the performers are posed as if for a still studio photograph. In terms of a newer generation of contemporary artists, Olaf Breuning, Rabih Mroué, Laurel Nakadate, Walid Raad, Jimmy Robert, Hito Steyerl, and Tris Vonna-Michell have distinctly used the photograph as a performative element in itself. In these cases, performance is amplified by the actual use of photographs. For instance, in Nakadate's *Lucky Tiger* series (2009), the artist, dressed in her "lucky tiger" bikinis, rehashes photographic conventions inspired by 1950s-style "cheesecake" and camera-club pictures. She then takes the pictures and places an announcement on Craigslist for middle-aged men to meet her and look at her photographs with inked**

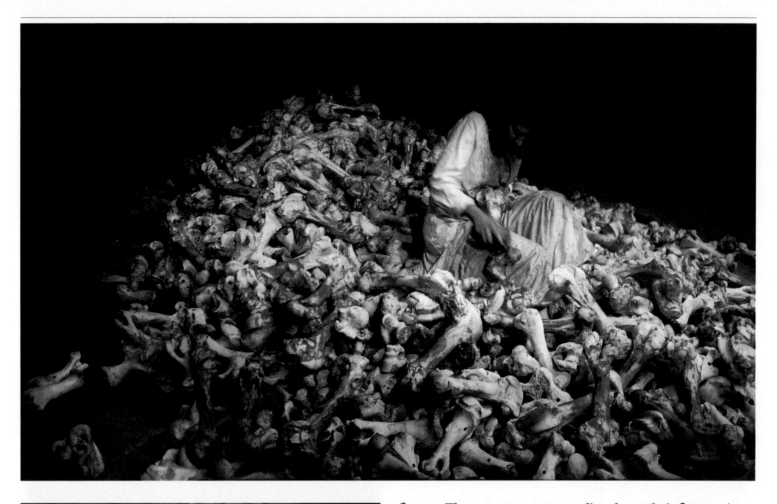

fingers. The anonymous accomplices leave their fingerprints on the pictures, and the resulting objects go beyond the performance itself and become documents of experience and fetishistic representation. Let's switch gears and speak about something else. Recent iterations of Performa have centered on a historical touchstone: Futurism in 2009, Russian Constructivism in 2011, Surrealism in 2013. How do you reconcile the liveness and presentness of the performance medium with an artistic movement predicated on documentation?

RLG: I am not one to say, "You had to be there." I wasn't at the Battle of Waterloo either. And indeed, this applies to knowledge in all its forms. In art history, we think that we know a painting or sculpture firsthand, but most of the time we do not. What we actually see and examine in real life is a fraction of what we know from studying, from an accumulation of knowledge *about* the material: newspaper cuttings, writings, drawings, photographs, history books, slide projections, film, and, more rarely, actually being there. Acquiring knowledge of the ongoing history of performance and the real impact of live performance in shaping art history of the twentieth century (and earlier), and making it known on as broad a scale as possible, to academics and curators as much as to the general public, is one of the main reasons I founded Performa in 2004. It was essential to open up this history, to make it known to a larger public and to the curators and critics who are just now absorbing that history in meaningful and radical ways. One of our most critical jobs at Performa is to act as a kind of "museum without walls"—to reveal the history of artists' performance not as a separate discipline but as one integral to the history of art.

RM: **Performance has expanded artistic vocabularies and contaminated artistic practices. In a 2014 article in the *New York Times*'s *T Magazine*, you were quoted as saying that**

In what ways has live performance changed our perception of the still image?

"Leonardo Da Vinci, Jackson Pollock and Cindy Sherman are all performance artists of one kind or another." What role does photography (and, by extension, other mediums) play in your consideration of Pollock and Sherman as performance artists?

RLG: With all due respect to the terrific writer at the *New York Times*, I did not label da Vinci, Pollock, or Sherman performance artists, per se. Rather, I made the point that artists have always created live performance—Leonardo would create events for the Sforzas, his patrons in Milan, and many Renaissance artists were involved with pageants and court events; it was part of their job description. And performative actions were the original source of Pollock's paintings or Cindy's photographs. Cindy was always "dressing up" and arriving at a friend's home or loft party as one invented character or another. That was the Cindy we all knew in the '70s in New York, and I have always considered her work to be driven by performance of that time and by the license it gave her to invent her own entirely personal repertoire of characters and images, and to record them in any way that suited her intentions—from small black-and-white photographs that she might have printed at the local Kodak store to the large-scale color photographs that she produces today. She is, indeed, an extraordinary performer. How else to explain her almost five-decade-long repertoire of endlessly individual and unique portraits?

RM: **Cindy is a phenomenal performer. The question is: What happens when the performer is no longer around? Take, for instance, the critical discourse around photography, in terms of original versus duplicate, or primary document versus a later printing, which persists in performance as well. What is your insight on the reenactment or reperformance of a work of art?**

Joan Jonas,
Reanimation, 2013
Photograph by Paula Court
and courtesy Performa

RLG: As every good teacher knows, one of the best ways to animate students and to have them fully understand ideas, of whatever nature, is to have them reenact work or experiments from the past. Reexperiencing a particular action—even if it is only a distant, out-of-context copy of the original—is one important way to get inside the piece, to empathize with the concepts that the artist was exploring. As more and more academics and curators get closer to understanding the history of artists' performance, the more the discussion about reenactment, the copy and the original, will come up as a fascinating way to learn about the shifting dynamics of culture, politics, and economics. The more knowledgeable and sensitive the curator to that history, the more relevant her selections will be and the more such work of the past can have meaning for artists and audiences in the present.

RM: Cultural theorist Mieke Bal called this dialogue between past and present, enactment and reenactment, "preposterous history." A good work holds this strange tension, and exhibitions ought to actualize all these temporalities. The permanence of the original is ensured by the transience of the copy. What about the post-Internet age? In an interview in 2013 with Andrew Goldstein in *Artspace*, when asked about the impact of the Internet on performance, you pointed out that online archives of documentary material provide unprecedented access to historic performances and amplify our knowledge of the discipline. How would you say that technology and social media have transformed the way we experience and document live art? Is the presentness of live performance antithetical to the urge to capture our experiences via social media?

RLG: My point to Andrew about online archives and being able to access this visual history is an extension of my comments on acquiring knowledge of this history. A painter will study the history of painting; a sculptor will pursue sculpture and books, and lectures. Performance documentation online has

only become available more recently, and so a young artist can now follow the work of Joan Jonas or Patty Chang, or Allora & Calzadilla, which they could not do before. This will, indeed, raise new levels of discourse, provide means for comparison and criticism, and provide those wishing to delve deeper into this material with a reference bank of images, processes, styles, and subject matter. At the same time, what is very exciting is the fact that the Internet and social media are the perfect platforms for live performance. Everything online moves! And artists who make performance are very aware of how their work looks on the small screen. The presentness of live performance goes hand in hand with the urge to document experiences via social media, because it is the live event that is the actual content. So, we're in a very good place.

RoseLee Goldberg is an art historian, author, critic, curator, and the founder and director of Performa, a nonprofit arts organization committed to the research, development, and presentation of performance by visual artists. The organization is now celebrating its tenth anniversary. Goldberg is the author of *Performance Art: From Futurism to the Present* (1979), a key text for teaching performance in universities.

Roxana Marcoci is Senior Curator, Department of Photography, at the Museum of Modern Art. Her exhibitions at MoMA this year include *Ocean of Images: New Photography 2015* (co-curated with Quentin Bajac and Lucy Gallun); *Transmissions: Art in Eastern Europe and Latin America, 1960–1980* (co-curated with Stuart Comer and Christian Rattemeyer); *Zoe Leonard: Analogue;* and *From Bauhaus to Buenos Aires: Grete Stern and Horacio Coppola* (co-curated with Sarah Meister).

On September 11, 2001,[1] applicant Moti Shniberg filed an intent-to-use application to register on the Principal Register the following mark, in standard character or typed form:

SEPTEMBER 11, 2001

[1] USPTO records indicate that the application was transmitted electronically at "17:37:56 EDT" on September 11, 2001. Therefore, the application was filed after events of the morning of September 11th.

Lebanese artists Walid Raad, Joana Hadjithomas and Khalil Joreige, and Rabih Mroué and Lina Saneh have all embraced the artist's talk to unpack history and the limitations of the photograph.

Lecture as Performance

Kaelen Wilson-Goldie

In the last twenty years, the Lebanese artist Walid Raad has produced two major, long-term, multifaceted bodies of work. The first, known as the Atlas Group, delves into the mechanisms of history and memory that have been used to convey the experience of Lebanon's civil war, a conflict that lasted roughly fifteen years, from 1975 through 1990. The second, titled *Scratching on Things I Could Disavow*, considers how the construction of institutions and infrastructures for contemporary art is changing the cultural landscape of the modern Middle East. Although one followed the other and they remain fairly distinct, the Atlas Group and *Scratching* are linked by several lines of inquiry and the strands of Raad's practice. Taken together, his projects involve an ever-expanding constellation of prints, photographs, Polaroids, drawings, cutouts, collages, sculptures, videos, Super 8 films, a white Fiat, plaster casts of a bomb crater, miniature exhibition models, monochromes, trompe l'oeil murals, a maze of fake doorways, and a dazzling cast of imagined characters, including a gambling historian, a melancholy intelligence agent, a sorrowful police inspector, a long-suffering photographer, a forgotten curator, and a pioneering performance artist who made gorgeous ink-on-paper abstractions in her youth.

The two projects meet at several important points of intersection, primary among them the formal precision of the lecture-performance, which extends through both bodies of work and is unique to the context from which Raad's practice first emerged. In the period after the civil war ended, the Lebanese capital Beirut proved itself a strange and powerful incubator for new thinking about art and photography, as a tight-knit group of colleagues took the setup and structure of an artist's talk to start an open-ended conversation about the behavior of images in proximity to wars and other forms of political violence. That conversation persists to this day. Raad is now one of the leading practitioners of the lecture-performance internationally, but his works continue to unfold in close dialogue with those of his Beirut-based peers, most notably the joint efforts of Rabih Mroué and Lina Saneh, who are rooted in theater, and Joana Hadjithomas jond Khalil Joreige, who come from the world of film.

The Atlas Group earned Raad a reputation as something of a trickster. When he first began showing his work in exhibitions, lecture programs, and film festivals in the late 1990s, he presented himself not as the author per se but rather as a spokesperson for a foundation that had been established to research the recent

history of Lebanon. The Atlas Group, according to Raad,
was based in Beirut, where its founding members were gathering
a wealth of documentary materials, including the photographs,
films, and notebooks filled with heavily annotated newspaper
clippings that Raad was sharing on their behalf. Within a
few years, the Atlas Group was revealed to be a clever fiction.
The colorful donors who had given the foundation their effects
were all, in fact, figments of the artist's imagination. Their
photographs were either found in the archives of Lebanon's
daily newspapers, borrowed from albums belonging to Raad's
father, or taken by Raad himself, when he was a teenager messing
around with his first camera on the eve of the Israeli invasion
of Lebanon in 1982.

However true or false, the Atlas Group was emblematic of
Lebanon's postwar era, a time for sifting through the wreckage
of the past to find the materials for building a better future, not
least through the creation of new institutions. By the time the
project came to an end, in the mid-2000s, the regional landscape
had shifted and another kind of institution-building took hold
of the artist's imagination—the creation of massive new museum
projects in the Persian Gulf. With no shortage of ambition,
the new cities of Dubai, Abu Dhabi, and Doha hoped to surpass
the old cities of Beirut, Cairo, and Baghdad as the Arab world's
preeminent centers of artistic production. Raad's second project,
organized in parts corresponding to the sections of a book
(preface, plates, appendices), has so far created (or imaginatively
recomposed) genealogies of Arab artists, bibliographies of Middle
Eastern modernism, and the oddly anachronistic architectural
details of future museums. Whole series in *Scratching on Things
I Could Disavow* sketch out a fictional prehistory and forecast
the opening scenarios for the branches of the Guggenheim
and the Louvre that Abu Dhabi is building on a spit of reclaimed
land known as Saadiyat Island.

Walid Raad, from *I Feel
a Great Desire to Meet
the Masses Once Again*,
2005. Performance with
slide show produced
by the Atlas Group
© Walid Raad and courtesy
Paula Cooper Gallery,
New York

To encounter Raad's work has thus become an exercise in entertaining doubts, skepticisms, and suspicions. The artist initiates viewers in a game of second-guessing, but at the same time, on a subtler level, he also engages them in a serious critique of photography, image making, and the status of art. Lavish in their materials and details, extensive in their background stories and accompanying texts, his works tend to be as accumulative and dense as they are conceptually succinct. How interesting, then, that the centerpiece of Raad's first major museum survey in the United States, currently on view at the Museum of Modern Art in New York, is neither a sequence of photographic prints purporting to show the engines that have been ejected from car bomb blasts (a hundred of them appear in the series *My Neck Is Thinner than a Hair: Engines* [1996–2001]), nor the videotaped eyewitness testimony of the only Arab hostage held with Americans such as Terry Anderson for a decade during the civil war (as conveyed in the sixteen-minute video *Hostage: The Bachar Tapes* [2001]), nor a collection of color-saturated still lifes capturing objects from the Louvre that will be inexplicably altered by their transfer from Paris to Abu Dhabi in 2026 (as imagined in the series *Preface to the Third Edition* [2013]), although all of these works are included in the show. Rather, the heart of the exhibition is an hour-long performance piece, which the artist is presenting more than seventy times in total—once a day, five days a week, for an audience of forty to fifty people each time.

Almost all of the works associated with the Atlas Group and *Scratching* exist in multiple formats. The dates, details, sometimes even the titles of individual pieces exist in a constant state of flux, changing from one context to another. But from their earliest iterations, both projects have always come across as the most seamless and conceptually airtight in the live performances that test the durability of Raad's materials, setting them down in a crosscurrent of politics, theory, and old-fashioned storytelling. *The Loudest Muttering Is Over: Documents from the Atlas Group Archive* (2003) established the setup, with the artist always seated at a table, a lamp, a bottle of water, a script, and a laptop before him, and a screen for the projection of images behind. *I Feel a Great Desire to Meet the Masses Once Again* (2005), about security panic and the war on terrorism in post-9/11 America and Raad's first work authored under his own name, was in many ways the hinge between the Atlas Group and *Scratching*. The same style of lecture-performance carries into the second project. *Scratching on Things I Could Disavow: Walkthrough* (2013), the core of the MoMA show, is the apotheosis of that project, and Raad's most theatrical work to date. It begins with an exposé of the Artist Pension Trust, an investment fund for artists; tunnels into the Israeli high-tech industry, data mining, and the algorithms turning seemingly irreducible works of art into tradable financial assets; and then jumps headlong into the future, to the opening of the Guggenheim Abu Dhabi, vaguely a decade from now, when an unnamed Arab artist will find himself mysteriously, inexplicably stricken, felled at the doorway, unable to enter.

Raad left Lebanon during the worst days of the civil war, when he was still in high school. He studied photography at the Rochester Institute of Technology, and he was one of the first PhD candidates in the University of Rochester's graduate program, then new, in visual and cultural studies. His work has always been indebted to and in dialogue with the history of photography and a lineage within Conceptual art lionized by Hans Haacke. But Raad's practice also came from a specific time and place. When the civil war drew to a close, he was one of a number of artists who lived abroad but returned to Lebanon often. A group of them began meeting to discuss, among other things, their work, the war just ended, and the contentious

Rabih Mroué,
The Inhabitants of Images,
2009. Detail from
performance
Courtesy the artist and
Sfeir-Semler Gallery, Beirut/
Hamburg

The lecture-performance is not unique to Beirut but the popularity and perseverance of the form there may well be.

reconstruction of the city at the start of the postwar period. Including Raad, Akram Zaatari, Jalal Toufic, Tony Chakar, Rabih Mroué, Lina Saneh, Lamia Joreige, Walid Sadek, Joana Hadjithomas, Khalil Joreige, Marwan Rechmaoui, and Ziad Abillama, among others, they gathered in an ever-changing rotation of old restaurants and cafés. They met formally and, perhaps because there seemed to be so much at stake in a city that had been so thoroughly destroyed, they argued fiercely.

The lecture-performance is not unique to Beirut but the popularity and perseverance of the form there—as well as the diversity of its many conceits and subjects—may well be. Raad has used it to tell the story of the Atlas Group and the shifting narrative of modern and contemporary Arab art. Tony Chakar, an artist and architect who is a close friend and frequent collaborator of Raad's, has used it to tell stories of another kind, drawing on poetry, popular songs, religious iconography, and Sufi texts to find metaphors for dealing with contemporary struggles and conflicts. Younger artists such as Haig Aivazian and Ali Cherri have created lecture-performances to reflect on the racial dimensions of the Dominique Strauss-Kahn scandal in New York and consider the nude male body in an eclectic collection of personal photographs, respectively. Rayyane Tabet, who works primarily in sculpture, and Marwa Arsanios, who mines the legacies of feminism and the Arab left, have both made public performances based on the very private act of reading.

While images are present in nearly all of these works, Raad has gone furthest to trouble the notion that photographs are reliable records of events, depicting reality or representing the truth. Alongside parallel projects by the artists and filmmakers Joana Hadjithomas and Khalil Joreige and the prolific performances

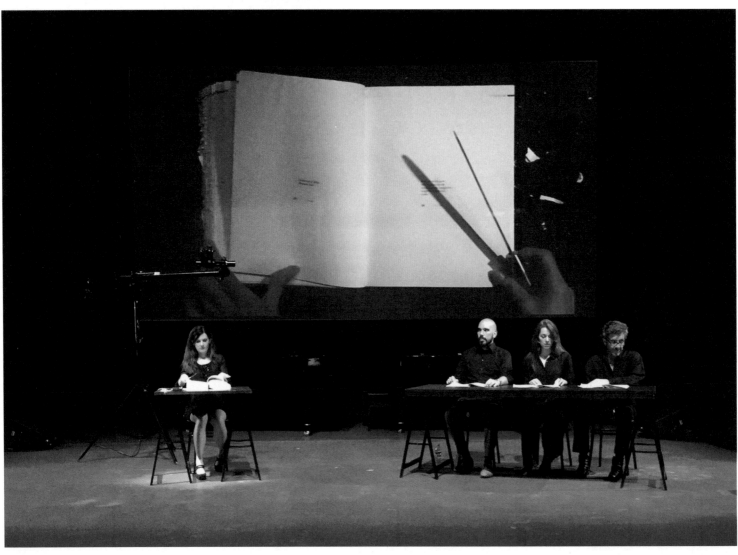

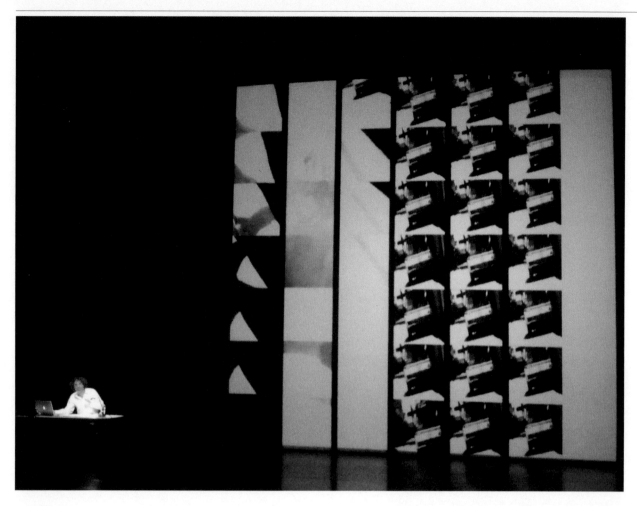

Rabih Mroué,
Pixelated Revolution,
a non-academic lecture,
2012. Performance
at Documenta 13,
June 9–September 16,
2012
Courtesy Sfeir-Semler
Gallery, Beirut/Hamburg.
Photograph by Pascheit
Spanned

The stories we tell ourselves in the aftermath of traumatic or historically consequential events are often more meaningful, truer to experience, than the facts of what happened.

of the artists and theater directors Rabih Mroué and Lina Saneh, Raad and his peers animate their photographs in front of an audience to articulate the uncomfortable position that the stories we tell ourselves in the aftermath of traumatic or historically consequential events are often more meaningful, truer to experience, than the facts of what happened. In the lecture-performances of all of these artists, photographs are necessary but they are also strangely, pointedly insufficient. They fascinate, but they do not support the facts. They conspire with rumor, intrigue, delusion, and misdirection to raise more questions than answers. Throughout, the photographs in these lecture-performances seem to serve another, quieter purpose, leading away from actual events to a more fanciful realm, where they spark the imagination and begin to act more like elements in live theater or literature.

Joana Hadjithomas and Khalil Joreige met as children in the mountain town of Beit Mery. Now based between Beirut and Paris, they have been working as a team for more than twenty years. Together they make feature films, experimental shorts, and essayistic documentaries on the malleability of images over time. *The Lebanese Rocket Society* (2012), for example, is a documentary that delves into the era before the civil war, Beirut's so-called Golden Age, but does so from an unexpected angle, following the story of a little-known group of Armenian students who, in the name of science, unwittingly entered Lebanon into the space race at the height of the Cold War. *Je Veux Voir* (2008), meanwhile, is a feature film starring Catherine Deneuve as a famous foreign actress touring the ruins of South Lebanon in the aftermath of the war with Israel in 2006, which marked the end of the earlier, postwar, reconstruction era, and signaled a shift in the work of many Lebanese artists, Hadjithomas and Joreige among them. As artists, they use poetic means and materials to tackle difficult issues such as the seventeen thousand people who disappeared in Lebanon and are

still unaccounted for twenty-five years after the war's end, or the experience of Khiam, the detention center run by the South Lebanon Army, Israeli's proxy militia, which was inaccessible for years and later bombed, turned into a museum, and bombed again.

Around the same time as the beginning of the Atlas Group, Hadjithomas and Joreige embarked on a long-term, multifaceted project of their own, titled *Wonder Beirut* (1997–2006). Proceeding in chapters and encompassing books, postcards, videos, photographs, and films, *Wonder Beirut* follows the story of a fictional photographer named Abdallah Farah. As the story goes, Farah ran a portrait studio in downtown Beirut before the war. As street fighting in the area intensified, he began burning his negatives to make the images conform to the reality that was rapidly changing all around him. Eventually, as the war ground on and on, he stopped developing his rolls of film altogether, preferring to describe the photographs he was taking instead. Those descriptions—following a moving exchange of letters between Farah, Hadjithomas, and Joreige—make up the script of the lecture-performance *Latent Images*, a work the artists only recently revived. It was performed every day for the entire six-month-long run of *All the World's Futures*, Okwui Enwezor's exhibition for the recent Venice Biennale.

Rabih Mroué and Lina Saneh, who never left Lebanon during the civil war but now spend much of their time in Berlin, were trained in a full-bodied tradition of theater, the most popular of all the fine and performing arts in Lebanon. Their first collaboration, when they were students at the Lebanese University, was the stage adaptation of an early novel by the influential writer Elias Khoury. Since then, Mroué and Saneh have always worked in tandem, sometimes jointly authoring their performances, sometimes alternating leading and supporting roles. The lecture-performance entered their oeuvre as a means of solving a problem they faced with realism in theater and the role of actors onstage. Like Raad, they have used the form to call photographs and other such documents into question.

Looking for a Missing Employee (2003) tells the true story of a man who disappeared from his job at a government ministry in Beirut. Mroué sits among the audience with a camera projecting his image onto a screen onstage, following the case through a barrage of notebooks and newspaper cuttings. The more we see, the less we know about what happened but the more we understand about the circumstances in which a man could vanish. *The Inhabitants of Images* (2009) and *The Pixelated Revolution* (2012) investigate disturbing photographic phenomena such as Hezbollah martyrdom posters (often doctored) and mobile-phone footage of snipers in the Syrian civil war. *Riding on a Cloud* (2013) turns to the story of Mroué's brother Yasser, who was shot in the head in 1978, and thereafter suffered from a strain of aphasia—he could distinguish objects in everyday life but not in photographs. "I had a problem with representations," Yasser says, seated at a desk onstage. In a passage that offers a poetic description of the entire Beirut-based, photography-driven, lecture-performance genre, he explains, "The memories in my head are like still pictures. There are no scenes from the past. My memories are motionless. Only pictures. One disappears and another appears. Most of the time I don't understand the connection between a picture and the one next to it. I need someone who knows me to tell me about it. In other words, I need someone to set the picture in motion."

Kaelen Wilson-Goldie is a contributing editor for *Bidoun* who writes regularly for *Artforum* and *Frieze*. She teaches criticism in the Department of Fine Arts and Art History at the American University of Beirut.

Pictures

Helena Almeida,
Inhabited Painting.
Acrylic on gelatin-silver
print, 1975

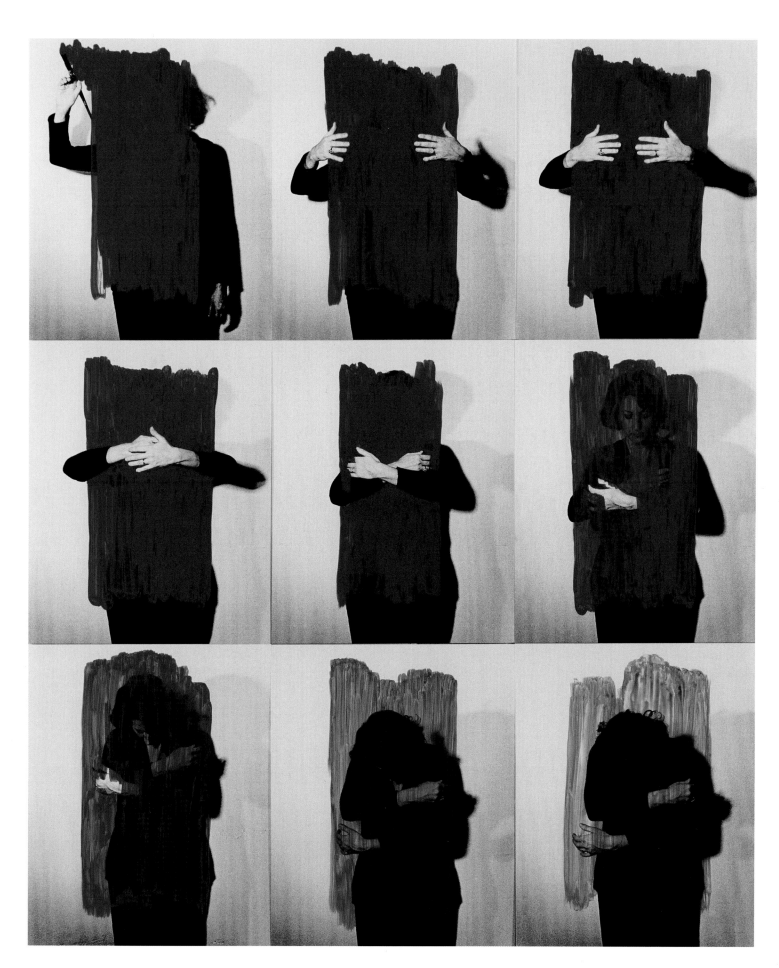

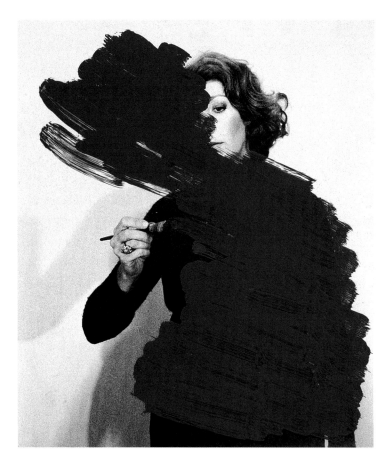
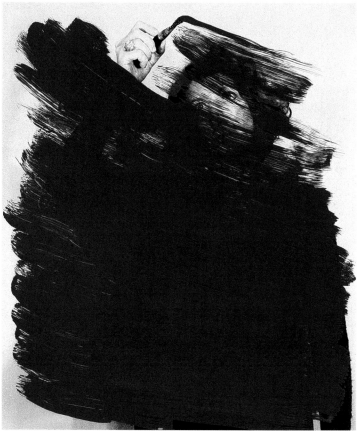
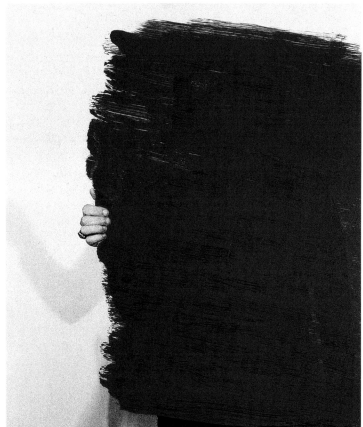
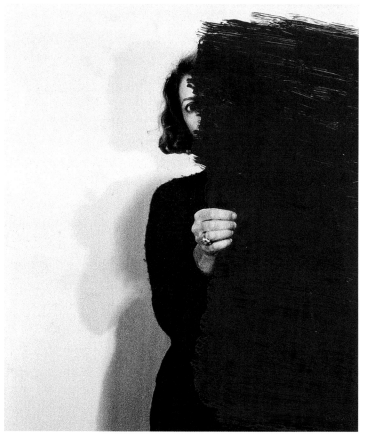

Inhabited Painting.
Acrylic on gelatin-silver
print, 1976

Helena Almeida

Delfim Sardo

Delfim Sardo is a curator
and writer based in
Lisbon. He is a professor
of contemporary art history
at Coimbra University,
where he also coordinates
the master's program
in curatorial studies.

In Helena Almeida's 1969 photograph *Pink Canvas for Wearing*, she is literally wearing a canvas, her arms wrapped in sleeves that seem to sprout from it. This is the first photograph of her career, after working for more than a decade as a painter since graduating from the Faculty of Fine Arts of Lisbon in 1955. In Lisbon's close-knit art scene of the 1960s, her importance among the Portuguese avant-garde, which included artists Alberto Carneiro, Paula Rego, and Lourdes Castro (most of whom were living abroad, far from the Portuguese dictatorship that wouldn't end until 1974), was confirmed by her solo show of three-dimensional canvases at Galerie Buchholz in 1967. Despite her increasing renown as a painter, Almeida's delight at discovering that she could function as a painting through the medium of photography is palpable in this lively image.

Italian artist Lucio Fontana's slashed canvases, which Almeida encountered in Paris in 1964, prompted her to start seeing the physical support used for painting—the canvas and the stretcher—as a vehicle for a spatial, conceptual approach to painting that takes the body as its principal point of reference. (Other influences at the time included the French New Wave, which piqued her interest in a conceptual approach to image making, as well as the work of Rebecca Horn, Urs Lüthi, and Jürgen Klauke.) Almeida's wearable canvases, which are applied to the body in the manner of orthoses, enable the literal embodiment of the painting and the transformation of the artist's own body into the support and its medium. "I was impressed by the obscure side of the slash, the mystery of what is beyond the canvas," she said in an interview in 2011. "But unlike Fontana, I wanted to do something that would detach from the painting. Instead of showing the reverse of the canvas, I went out of the canvas."

A concern with drawing also informs much of Almeida's work, and she treats the surfaces of drawings or photographs as portals for crossing from the domain of representation into the realm of physical space. In her series of drawings *Inhabited Drawing* (1975–77), she makes a line materialize (actually a piece of horsehair) and physically snake its way through the space of the image. As the artist described the process in 2006: "I passed to photography through drawing. The drawings with strings [the collages with horsehair] made me use photography. I wanted to grab the string with my own fingers to demonstrate that the line in the paper had become solid."

While the artist's initial forays into photography are grouped together as *canvas(es) for wearing* (1969–70) or, later, *Inhabited Painting(s)* (1975–76), subsequent pieces would incorporate a number of key forms of expression, including the series titled *Studies for Inner Enrichment* (1977). In this last body of work, a rich blue paint, somewhere between ultramarine and cobalt, is layered on top of the photograph, sparking little narratives: at times the artist seems to be swallowing or regurgitating the paint, weeping blue tears, slipping it into her pocket like a talisman, or embracing it, incorporating it into herself as she gradually blurs and fades away—almost like a process of transubstantiation. While the project has eucharistic connotations, here the artist's body is made visible by the fading of the blue color, highlighting the difference

between the surfaces of painting and the flatness of the photographic image. Almeida has used the stringency of the grain in high-contrast photography to rob the pictures of their photographic poetry and render them purely documentary.

In the late 1970s Almeida embarked on a vast multimedia series, *Feel Me, Hear Me, See Me* (1978–80), in which the commands of the title allude to a series of complex and contradictory situations. The *Feel Me* images are beset with representations of the impossibility of feeling the other, featuring images of closed eyes; the *Hear Me* images are based on the difficulty of communication, illustrated (among other groups of images) via eight photographs of Almeida and her husband (and work partner), Artur Rosa, facing each other, their mouths connected by what seem to be thin sheets of paper that materialize breath; and the *See Me* work features an amplified recording of graphite on paper, the sound of a drawing being made. About this sound piece, Almeida wrote in 1979, "I used to think how I would like to hear-see my drawings. So I have recorded some of them.... In so doing I had no rhythmical or musical intent but I welcomed in surprise their breathing and rhythm."

Helena Almeida is now eighty-one, and, although she has been exhibiting internationally since the 1970s, the idiosyncratic character of her work and the profound originality of her approach don't allow for any easy interpretation. Even in her native Portugal, recognition of her work has been slow: when she had a retrospective exhibition in Lisbon in 2004, it was the first time her work had been on view in a Lisbon museum since 1983. The retrospective exhibition that is now on view at the Serralves Museum of Contemporary Art, in Porto, and that will travel to the Jeu de Paume, in Paris, and to Wiels, in Brussels, in 2016, will be an occasion to see her work as belonging to a generation of artists who examined the relationships between the body, images, and physical space.

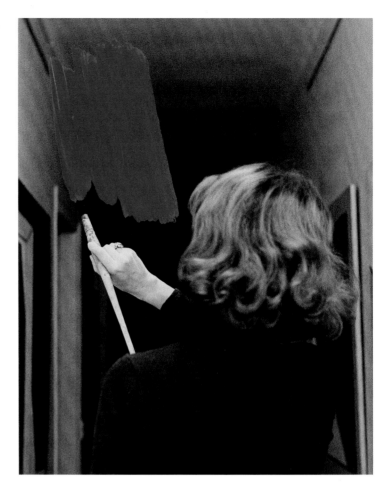

Study for Inner Enrichment. Acrylic on gelatin-silver print, 1977
Courtesy Portugal Telecom Collection

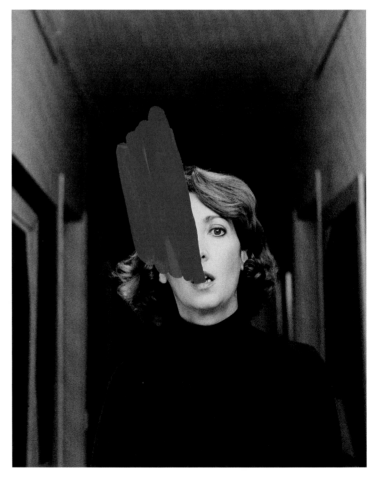

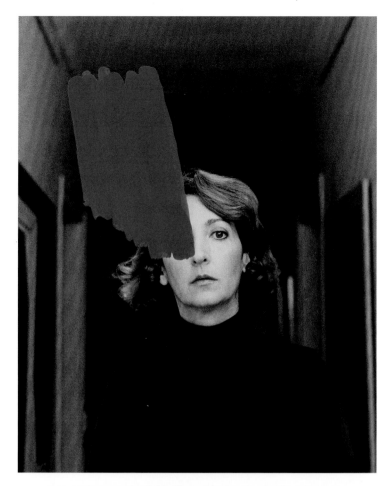
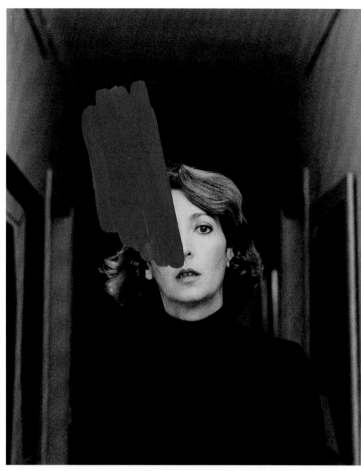
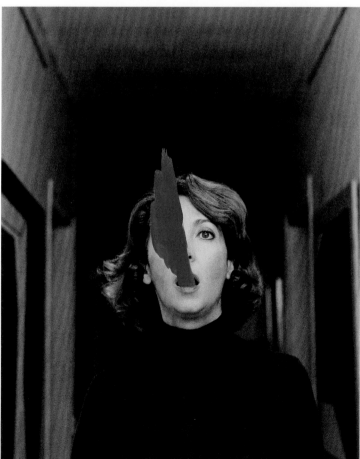
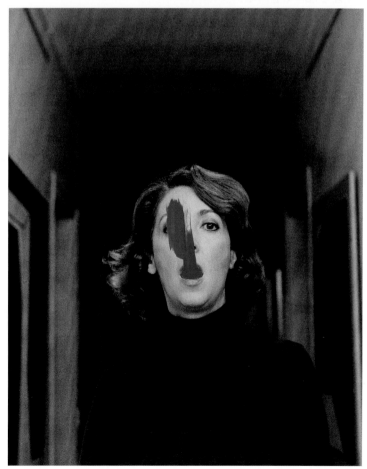

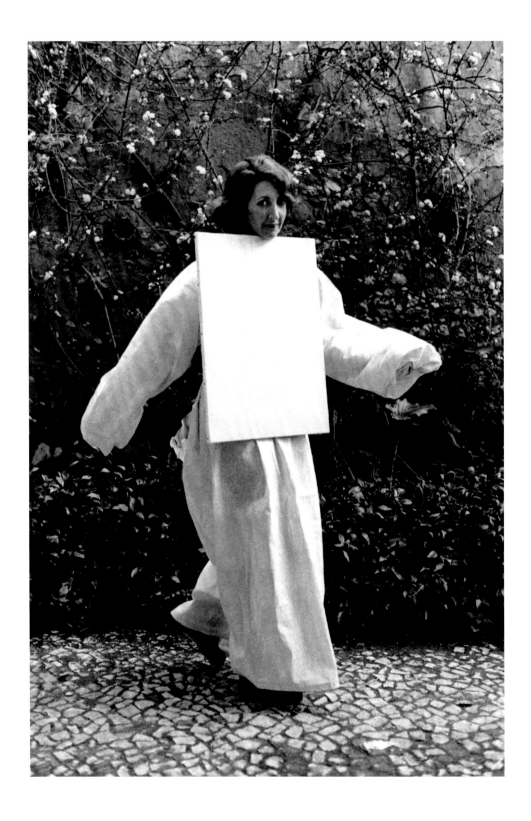

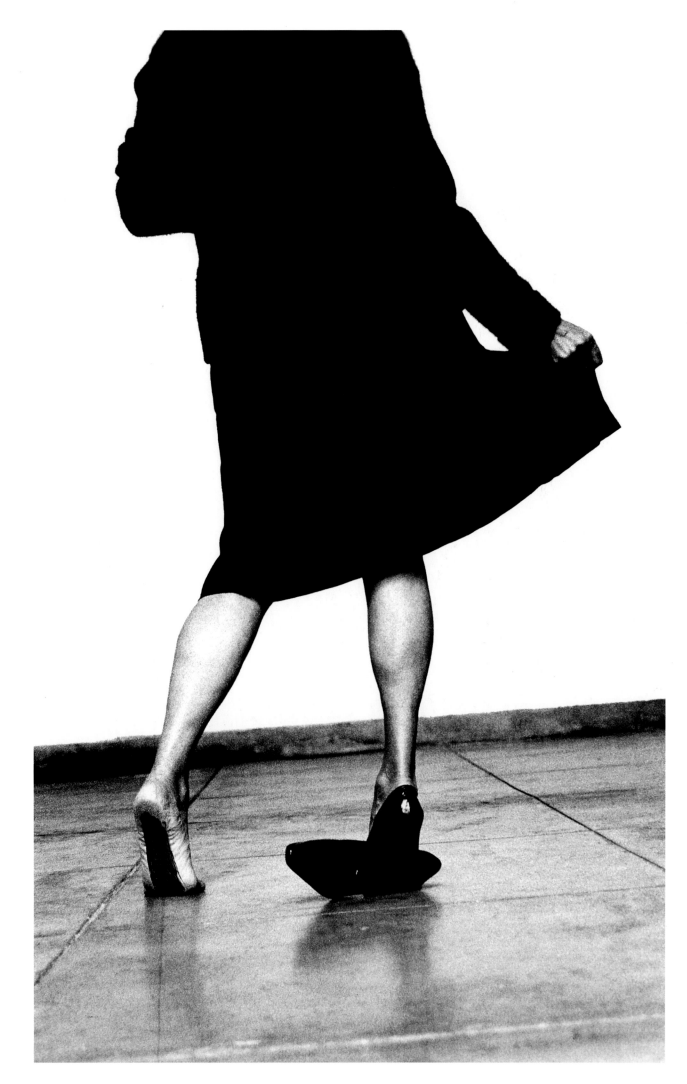

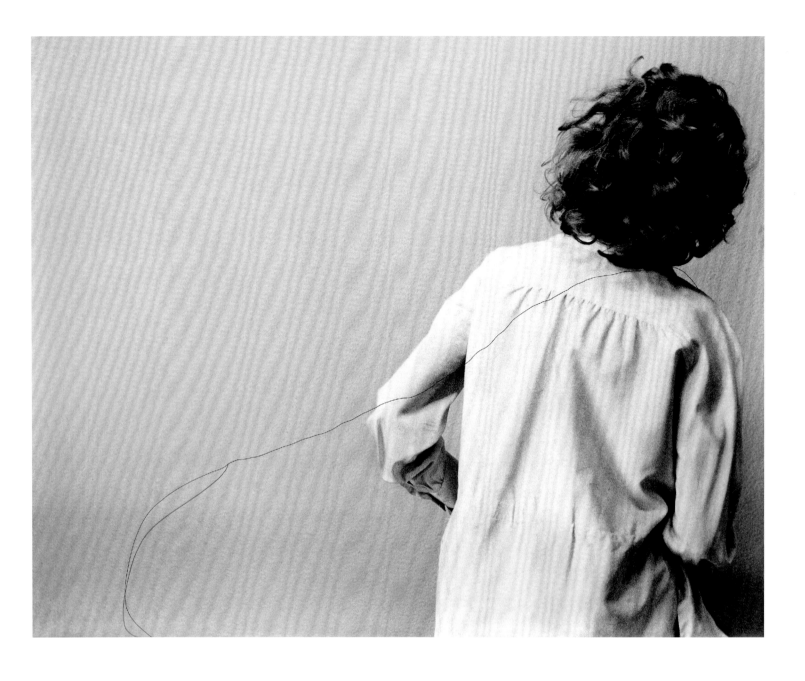

**This spread and overleaf:
all photographs from the
series Inhabited Drawing.
Horsehair on black-and-
white photographs, 1975**
Unless otherwise noted,
photographs courtesy
Galería Helga de Alvear,
Madrid

"Who poured the paint?" I asked Torbjørn Rødland recently over Skype, referring to *Pump* (2008–10). "I did," he replied, adding, "I cannot delegate important tasks like these." The Los Angeles–based Norwegian artist's answer, an assertion of control over a situation governed by chance, hints at the tension that characterizes many of his photographs. It is similar to the tension of live performance, in which a structure or script comes to life through people who bring to it their interpretive prejudices and their frailties—and who can't always control environmental factors. At another moment in our conversation, Rødland elaborates, "I've learned to trust that what I'm handed is better than what I could possibly plan for. This is, of course, after having planned certain things, or initiated a situation, or set a stage for invited performers."

Rødland's stage sets are often non-descript—a domestic interior, a clearing in the forest, a blank studio wall—and thus allow viewers to concentrate on the action occurring within them. A young woman in a leotard and saddle shoes lies prone on a kitchen countertop, contorting her body as she holds her feet near her ears. Another wears high-top sneakers on her hands, which rest on the ground in a pose that gives her the appearance of an animal standing upright, delicately and awkwardly, for the first time. A colorful heap of marker strokes, made by an unknown hand, cover a preteen boy whose arm is in a cast. These events are so unusual they seem to occur solely for the camera's gaze; their absurd specificity removes them from the flow of everyday life. Put another way, his photographs are not "decisive moments" but dispatches from another realm, one that exists in parallel to our world. That sense of separateness is heightened by how absorbed Rødland's subjects are in their inscrutable rituals. They rarely gaze directly into the lens, and therefore seem unwilling or unable to acknowledge us.

The artist's midcareer survey, presented earlier this year at the Henie Onstad Kunstsenter in Oslo, outlined significant changes in his art over the last twenty years. He no longer appears in his own pictures, as he did during the mid-1990s. He collaborates with friends, colleagues, and acquaintances. Now he often photographs two or more people, rather than individuals. He no longer works in series. These developments, though seemingly small, tangibly affected his photographic process. "It made me more productive," he says. By choosing not to place his pictures into predetermined categories, Rødland is free to create whatever "tragically vague inner image" comes to his mind. At any given moment he has dozens of completed photographs waiting for an appropriate context in which to be published or exhibited. (A date like 2011–15 indicates the gap between when the negative was exposed and when the first print was made.) When a batch of Rødland's photographs is gathered together, then, the connections among them are suggestive, aleatory, wonder inducing.

In our conversation, Rødland used the word *weak* in several contexts: "There's no need to do a weaker version of something one has already made." The language suggests art making as athleticism, and successful pictures as mastery over countervailing forces. Perhaps the greatest forces to overcome are social and pictorial conventions: genre clichés and good manners. When I asked if the camera gives him license to do—and reveal—things that would otherwise seem unacceptably strange, his response neatly summarized the disquieting appeal of his photographs. "Having to convince strangers to give physical shape to 'unacceptable' situations is harder than just moving a pencil. But there's also an enormous reward."

Torbjørn Rødland

Brian Sholis

Brian Sholis is Associate Curator of Photography at the Cincinnati Art Museum.

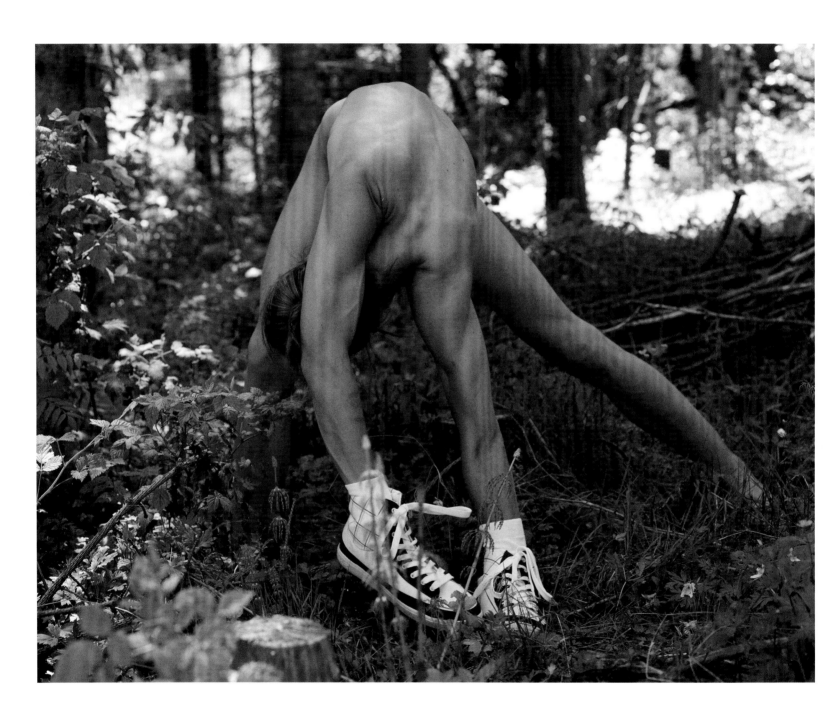

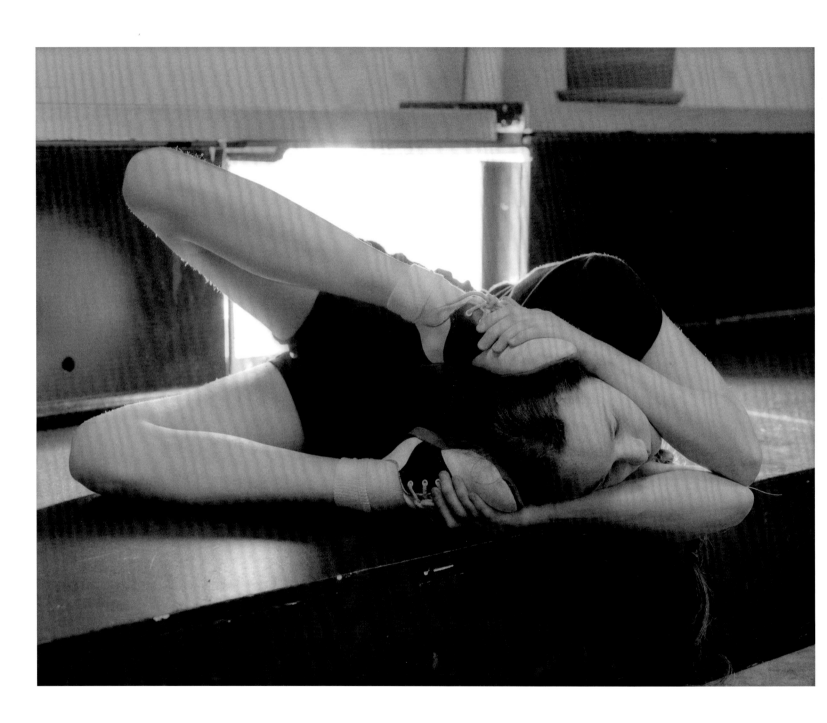

This Is My Body, 2013–15
All photographs courtesy
STANDARD (OSLO), Oslo;
Air de Paris, Paris;
Algus Greenspon, New York;
and Nils Stærk, Copenhagen

Over the past five years I've slowly returned to dance. When I was an undergraduate art student in the early 1970s, I spent a year studying and performing modern dance at the University of Pittsburgh. My immersion in dance was intense but short-lived. After dance, I moved to photography, which I took up full-time in 1976.

In 2013 I began to make color photographs by placing three black-and-white photographs into the red, green, and blue color channels of Photoshop. The results were crude and not very appealing. Over the next year I refined the color management by using hue and saturation, selective color, gradient mapping, and channel-mixing adjustment layers. Each photograph is made this way. I copy a separate black-and-white photograph into one of Photoshop's color channels and then fiddle with it until the color works. All of the photographs in *Dance Project* feature three types of images: dance, architecture, and landscape. The result resembles a multiple exposure. In the transition from analog to digital photography, one of the things that disappeared was the multiple exposure. While it's easy to layer two or more photographs in Photoshop, channels create multiple exposures that feel more like the inadvertent double exposure of film technology. I am continually surprised by the strange images that I create using color channels.

My appreciation of random image combinations came from my father, who collected makereadies from the printing company he worked for. A makeready is an artifact of offset printing. Scrap paper is run through the press to get to the correct speed and even ink distribution, then saved to be reused. You might find a calendar grid printed over a textbook page atop a dog-food advertisement.

In the first six months of working on this project, I posed UCLA art students in the studio using a Xerox book of dance imagery I had created from the history of dance photography. In January 2015 I began to photograph professional dance companies in rehearsal.

Last year I photographed a gigantic circular Marcel Breuer building in Boca Raton, Florida. The building is elevated on cast concrete piers, a common device Breuer used in the 1950s and '60s. My Breuer photographs were still in my digital camera when I began photographing dancers. I needed an additional element to complicate the dance imagery, and the Breuer building was perfect, conceptually and formally. For one thing, architecture has a strong somatic connection to dance. Both govern the body but at vastly different scales, and the bodies of the dancers intersect the architectural space in unexpected ways. With a Breuer photograph as one of the channels, the dark shadows from the building cut into the RGB color space, dramatically bringing forward or suppressing parts of the overall image.

The landscape components of the dance photographs derive from recent excursions to a large open space in western Connecticut. I walked and painted these fields when I was an adolescent, and during my brief involvement with dance I imagined these fields as spaces for my choreography.

James Welling Dance Project

James Welling's work was recently on view in *Things Beyond Resemblance: James Welling Photographs*, at the Brandywine River Museum of Art in Chadds Ford, Pennsylvania.

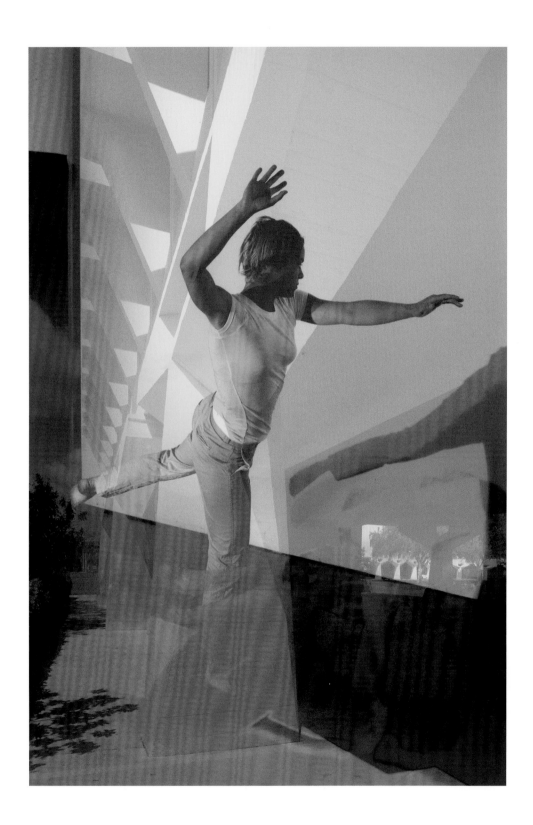

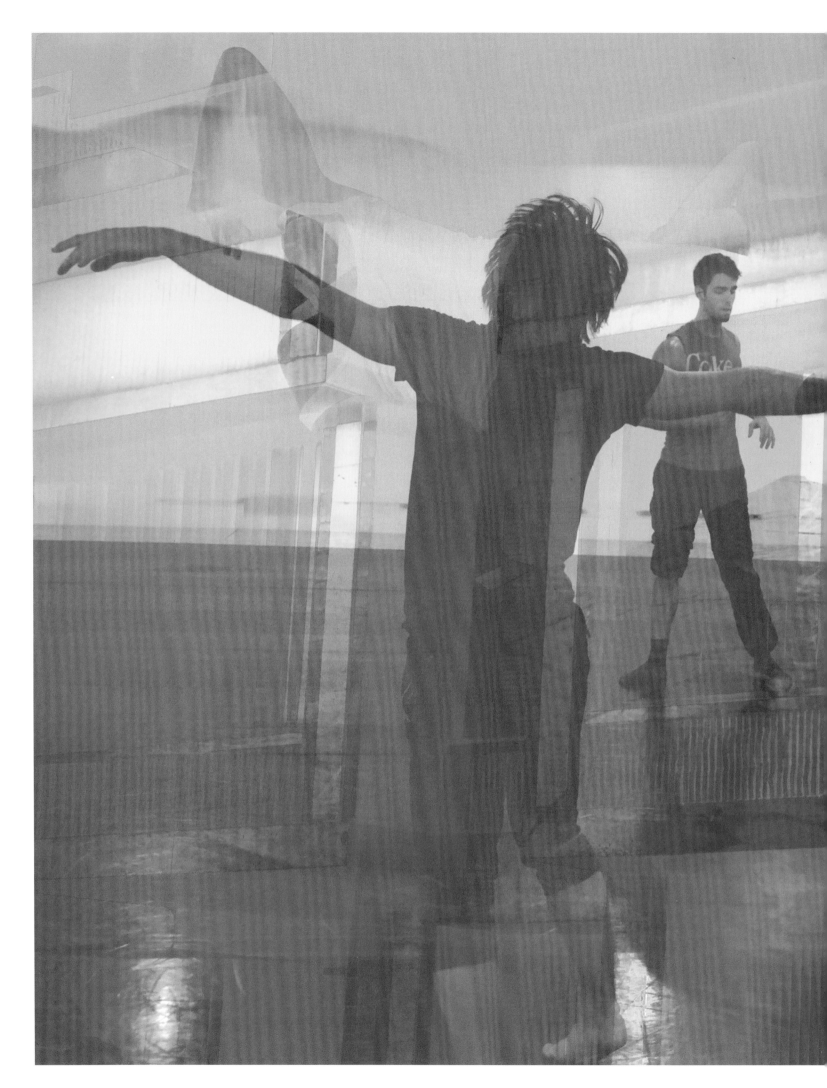

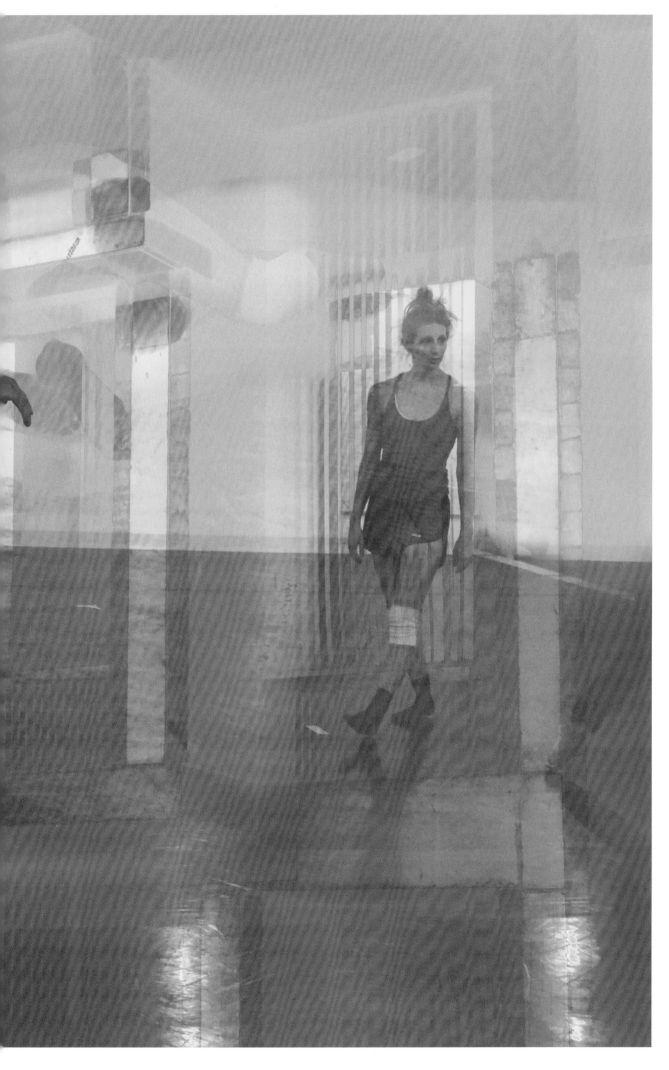

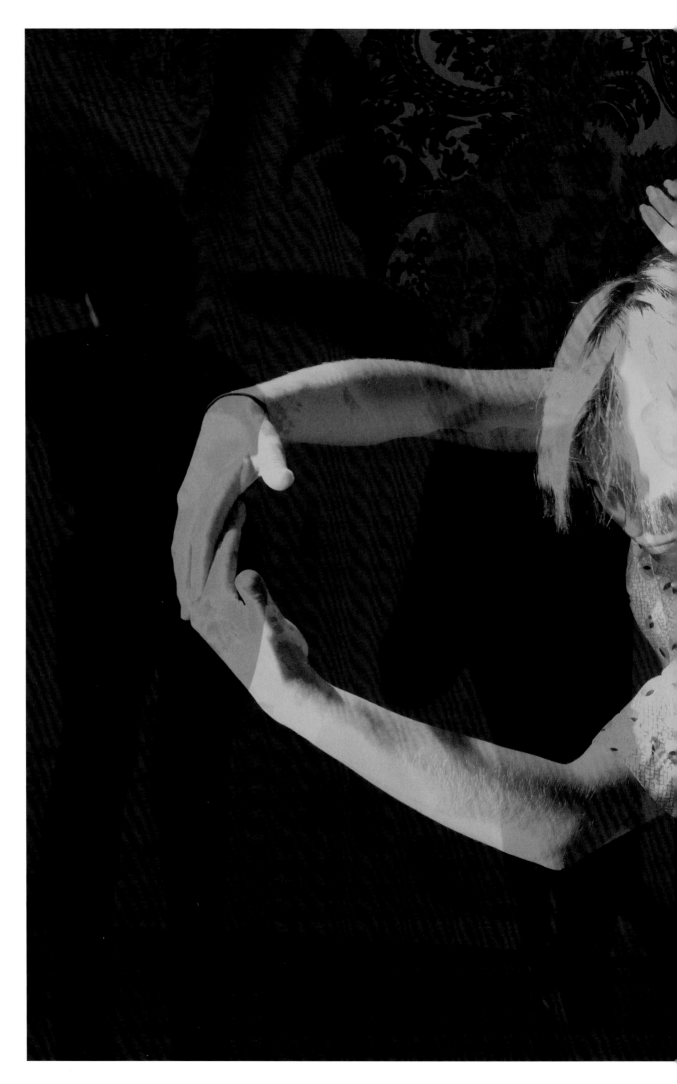

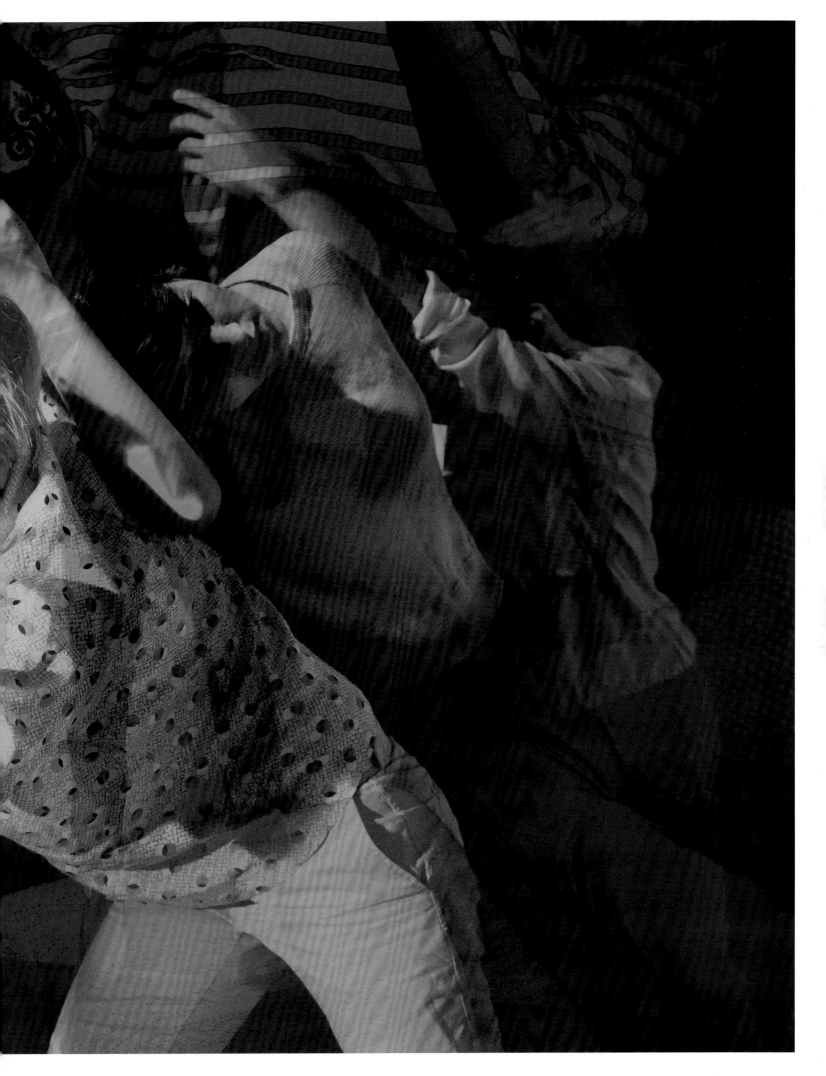

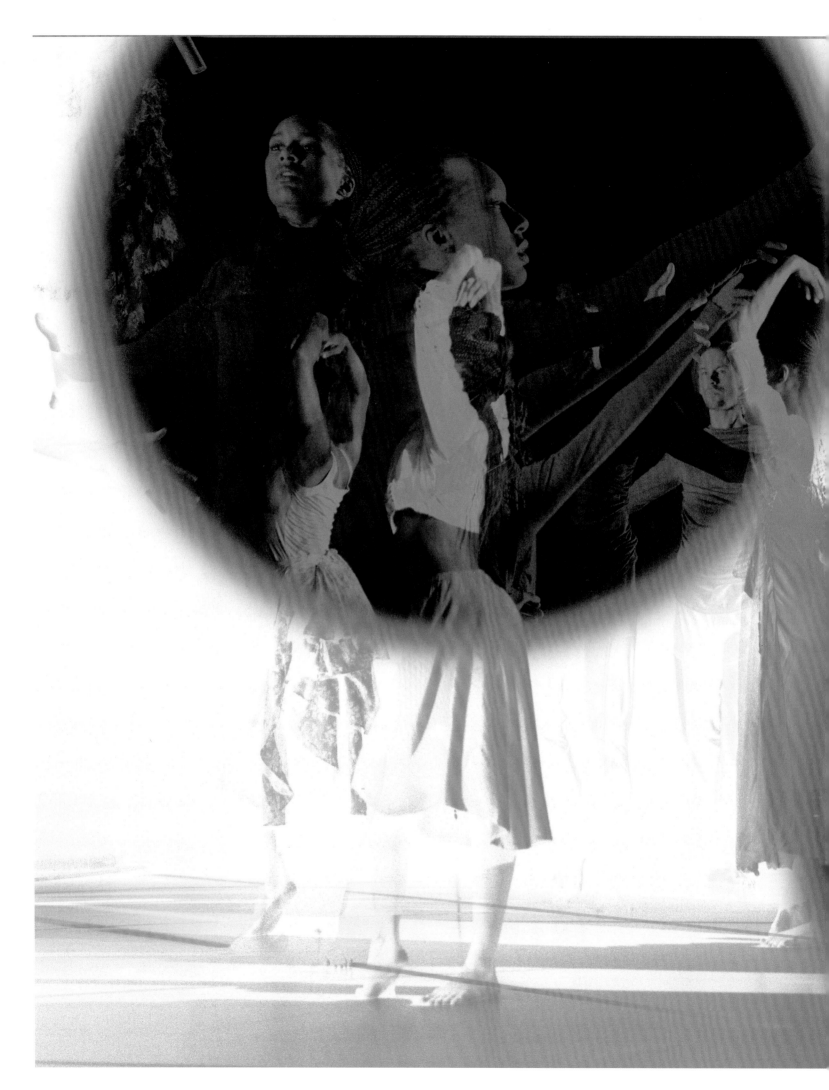

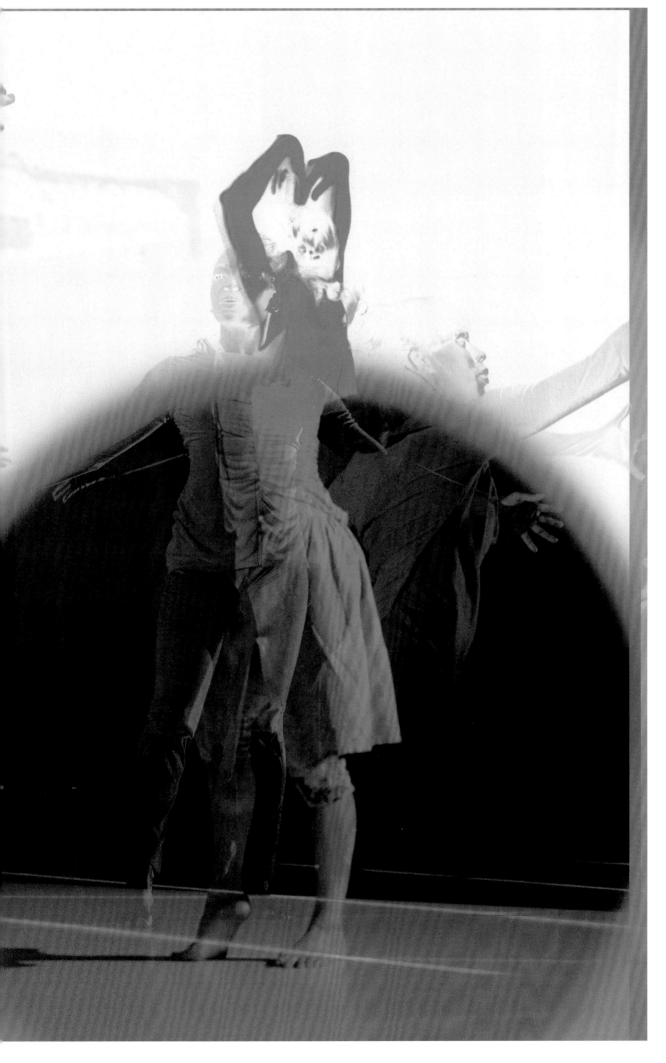

Untitled (UD), 2014
All photographs from
Choreograph, 2014–15

Courtesy the artist,
David Zwirner, New York/
London, and Peter Freeman,
Inc, Paris

Thanks to Untitled Dance,
L. A. Dance Project, and Kyle
Abraham/Abraham.In.Motion

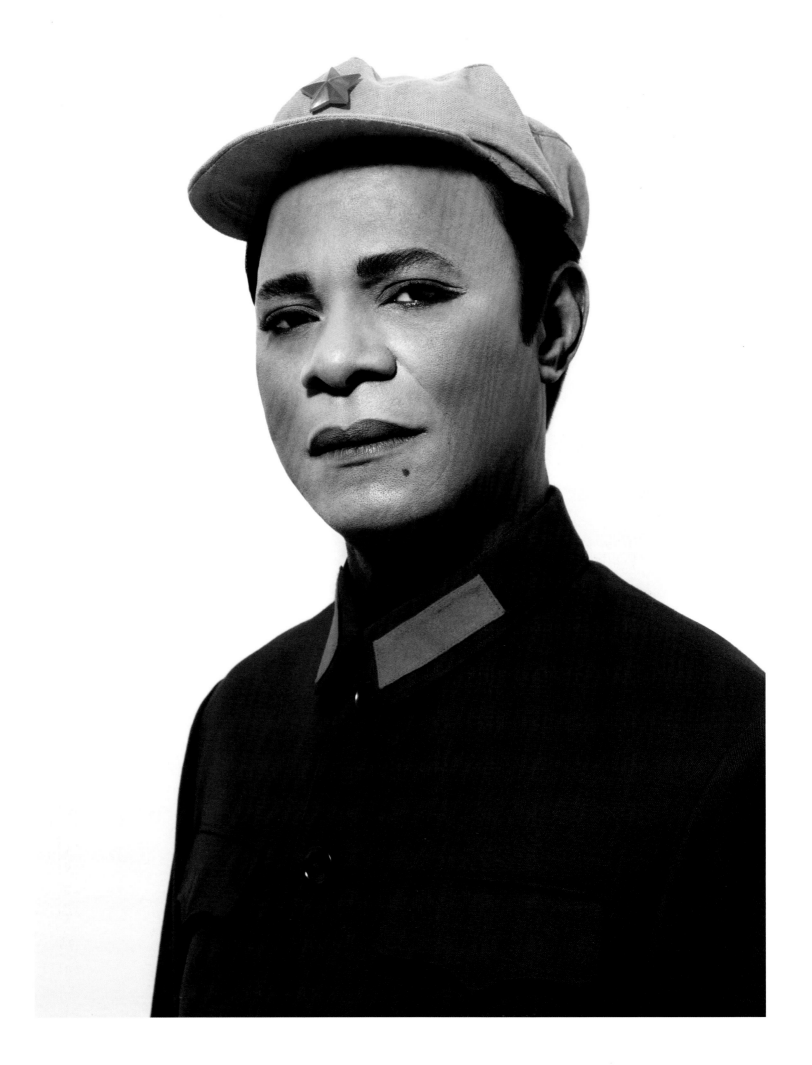

As a teenage photographer and commercial portrait–studio owner in Bangui, Central African Republic, in the 1970s, Samuel Fosso took turns between client sittings in his studio to reel off self-portrait after self-portrait, modeling the fashion of the day: colorful platform shoes, bell-bottomed pants, huge dark sunglasses, tight-fitted shirts, and blowout Jimmy Cliff rude-boy fisherman hats typical of postcolonial African urban youth of the period. Using his own body and the nonchalant, adventurous power that only a teenage studio proprietor could wield, Fosso produced a formidable look book of African urban youth style in the wealthy, immediate postindependence decade.

After those images were discovered in the 1990s, their cultural significance brought Fosso into a vibrant circle of young African intellectuals: writers, international curators, and artists like Simon Njami and Bili Bidjocka, Okwui Enwezor, Iké Udé, Yinka Shonibare and this author, and Congolese urban chronicler Chéri Samba, among others. He inadvertently became part of a larger conversation, an emerging postcolonial African cultural movement, no less, that was searching for new languages and meanings, and engaged in deeper historical preoccupations relevant not just to the youthful, curious ego, but even more so to that great task that Frantz Fanon posed their generation: to discover its mission, fulfill it, or betray it.

The matrix of social, historical, and conceptual investigations that this movement engaged in began to steer Fosso's application of the self in front of the camera beyond his earlier preoccupation with the adolescent ego. Before him, Udé was also using self-portraiture, or what he referred to as "the regarded self," in even more diverse ways—to not only construct critiques of race and representation but rediscover and reinvent the complexities and subtleties of traditional West African ideas of beauty, gender fluidity and role reversal, and theater. Udé's engagement with his native Igbo traditions of body art and performance, especially Igbo masquerade traditions, certainly held profound meaning for Fosso, who shares the same Igbo heritage, and it was by performing the persona of his late grandfather, an Igbo deity priest, in his series *Le rêve de mon grand-père* (The dream of my grandfather) in 2003 that Fosso completed his conceptual transition.

Subsequently, in the series *African Spirits* (2008), in which he reenacts iconic images of African independence and liberation struggle leaders like Kwame Nkrumah, Samora Machel, Haile Selassie, and Nelson Mandela, Fosso in fact created a parallel to the Igbo tradition in which adepts or community members don masquerade costumes to channel ancestral spirits during festive seasons. By donning the costume and transforming oneself into a masking figure, one took on the persona of a visiting ancestor and served as a symbolic or ritual bridge between the past and the present, and even between the sacred and the quotidian. In *African Spirits*, Fosso transformed himself into a masquerade of sorts, through which the spirits of the guardians of African liberation were made manifest.

In *Emperor of Africa* (2013), his most recent series, Fosso channels a different spirit by restaging iconic images of Chinese leader Chairman Mao not only as a liberator who, like the subjects of Fosso's *African Spirits* series, is highly admired in Africa, but also as the founder and symbol of a modern imperial behemoth that is currently engaged in an expansive long march across Africa. Though China's growing economic and cultural presence is eagerly embraced by many African leaders, it has raised concerns, especially among the continent's intellectuals. In a complex, richly layered performance worthy of an African masquerade, Fosso's Mao is both ancestral figure and absent dictator, almost like the patriarchal leader in Gabriel García Márquez's 1975 novel *Autumn of the Patriarch*, who's never seen yet looms large over his dominion. Fosso, as performer, is both subject and inquisitor, the man behind the mask who interrogates empire and postcolony alike, the ultimate Fanonian "man who questions."

Samuel Fosso

Olu Oguibe

Olu Oguibe is a professor of art at the University of Connecticut.

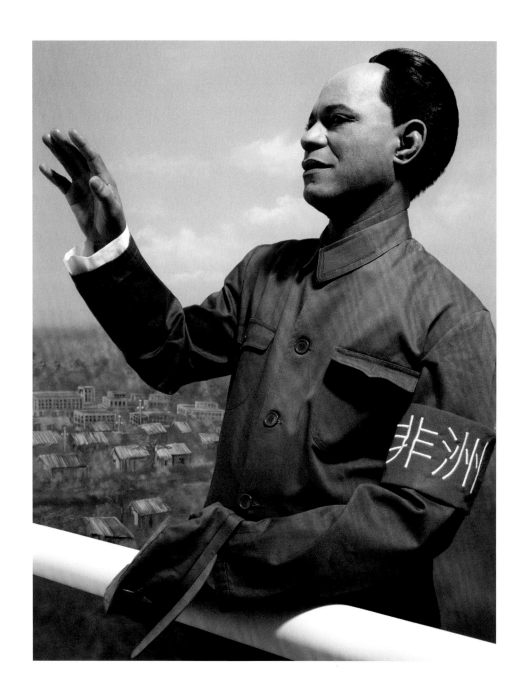

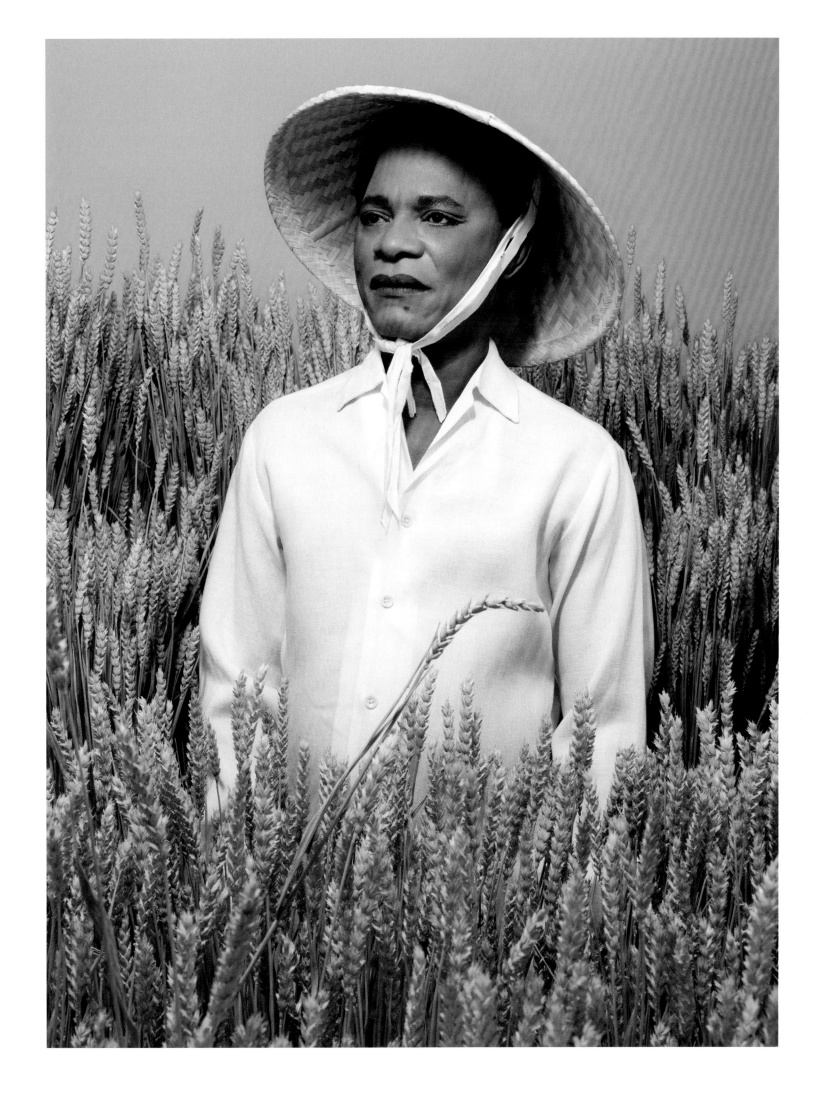

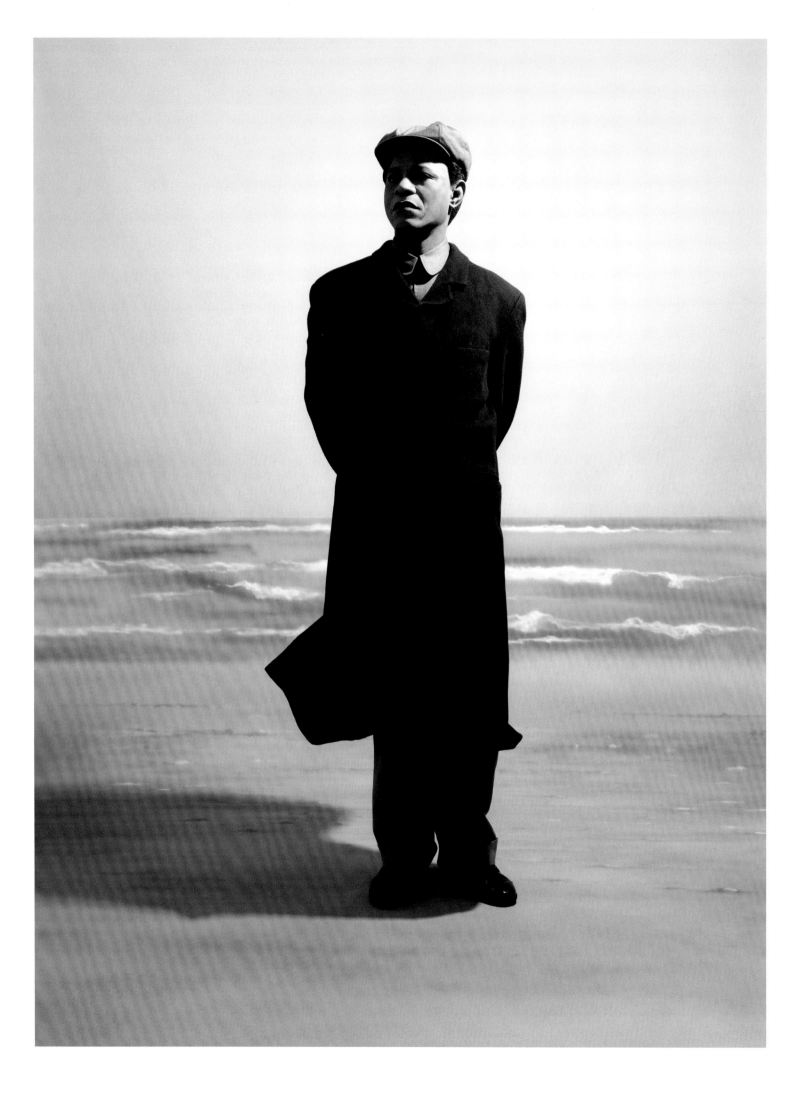

All photographs *Self-Portrait as Mao Zedong*, 2013, from the series *Emperor of Africa*, 2013
© Samuel Fosso and courtesy Patras/Paris

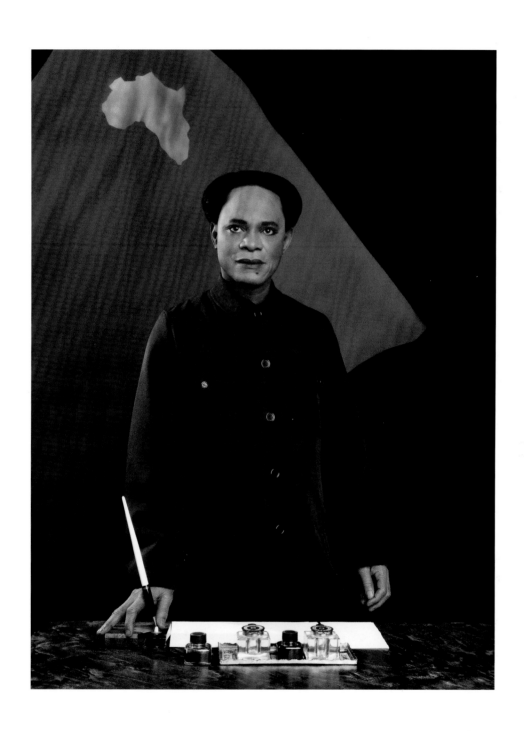

Dru Donovan's series *Lifting Water* restages scenes and gestures and bodily attitudes from the time she spent caring for a dying friend, her former teacher and mentor. Enacted and photographed in a motel room over several consecutive weekends, the series shows the same portly bald man in late middle age in the role of the dying person, while a rotating cast play the carers who lift and wash him, laying comforting hands upon this body which is dying and not dying. Working with a variety of formats—view camera, digital SLR, 35mm point-and-shoot—Donovan essays a typology of vulnerable, tender, and exhausting poses. Here is the ailing body isolated in bed, raised on all fours with hands clasped as if in prayer, submitting to the ministrations of other bodies, or half sunk beneath the bedclothes, on the point of disappearing. Among the striking tensions in the photographs is the man's tractable weight and heft and the way his gaze drifts past camera and carers, lost in gratitude, pain, or even shame.

Donovan, who is now based in New York after relocating from the West Coast, has long been exercised by the theatrics of pain and passivity. Her ongoing series *Carving the Lung* depicts many such instances of ambiguous attention and bodily being-together. Two teenage boys support a third by the shoulders: Is he drunk, stoned, or worse? Seen in a mirror, one man lifts—or is it dumps?—another, who looks drowned, lost, ruined. Even workaday scenes of professional physical care seem fraught: a pair of hands lightly held by those of a manicurist, a woman's head thrown back in a hairdresser's basin. And what, precisely, is a blonde woman in white doing to her near-doppelgänger when she holds her tightly by the jaw and brandishes a pair of false eyelashes so awkwardly in front of her face?

Carving the Lung, like a lot of Donovan's work—such as a recent series about stop-and-frisk, the controversial police tactic used in New York City—is as much concerned with conscious performance and self-presentation as it is with these episodes of enigmatic frailty and submission. Yet there are also moments of self-reflection or invention. In a separate sequence another young woman, an actress, rehearses fifteen poses that mimic the critically overthought category of the selfie, but suggest too an anxious care for the self.

Dru Donovan

Brian Dillon

Brian Dillon is UK Editor of *Cabinet* and teaches critical writing at the Royal College of Art. His recent books are *Objects in This Mirror: Essays* and *Ruin Lust* (both 2014).

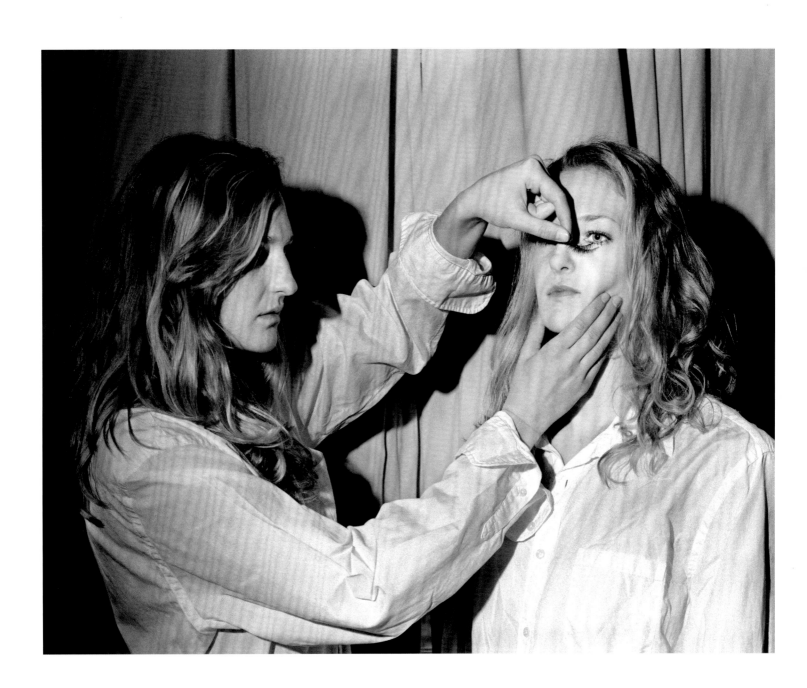

This page and opposite:
Untitled, 2010, from the
series *Lifting Water*

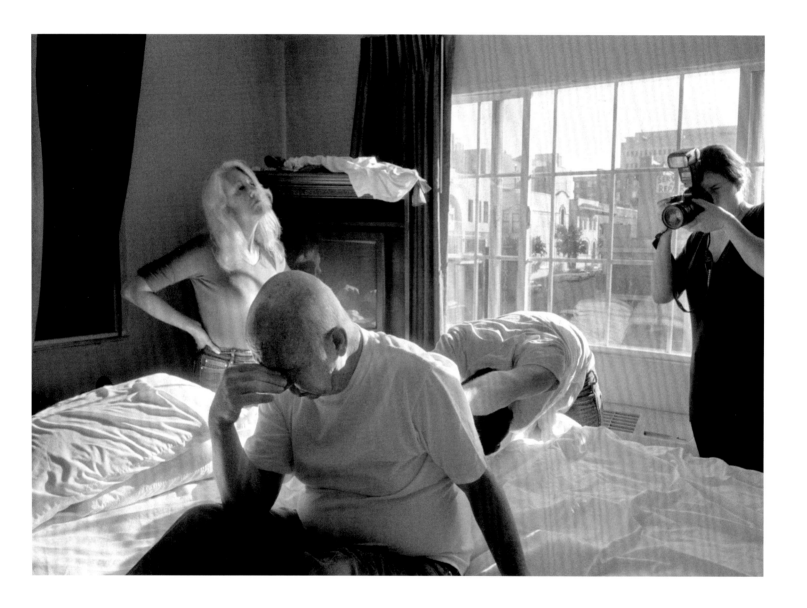

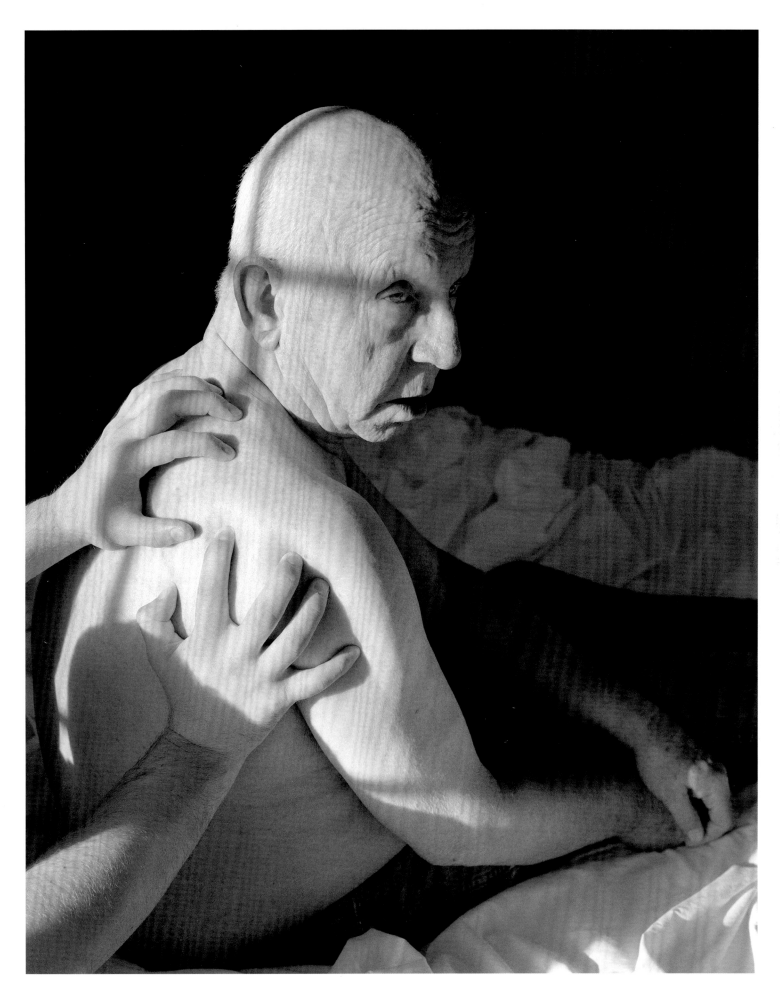

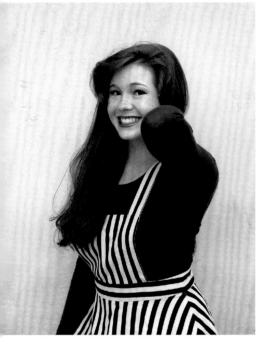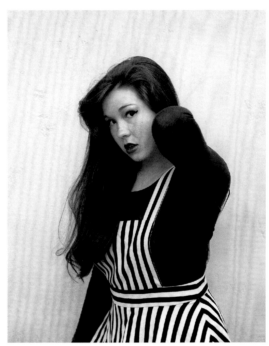

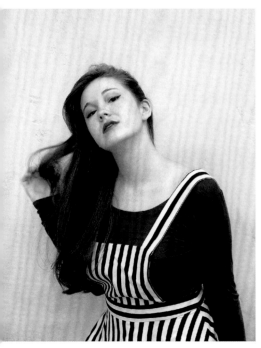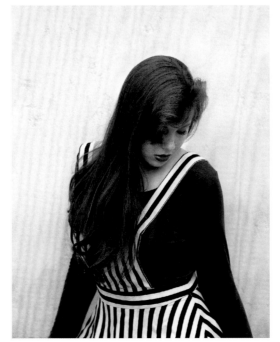

Untitled, 2009, from the
series *Carving the Lung*
All photographs courtesy
the artist

Carrie Mae Weems

Adrienne Edwards

Untitled (Yellow Painting),
2003–5

Performance may not immediately come to mind when one thinks of prolific conceptual artist Carrie Mae Weems (born 1953, Portland, Oregon). Yet Weems's foray into art began with participating in Anna Halprin's San Francisco Dancers' Workshop at the age of seventeen. Halprin, an experimental dance legend, is known for her shared aesthetic sensibility to that of minimalist choreographers Yvonne Rainer and Trisha Brown, who collaborated with visual artists Robert Morris and Donald Judd, respectively.

Drawing on four bodies of work made over twenty-five years, including *Colored People* (1987), *Beacon* (2003–5), *Africa: Gems and Jewels* (1993/2010), and *Blue Notes* (2014–15), Weems's self-selected portfolio opens with *Untitled (Yellow Painting)* (2003–5), an indelible image of the artist with her back to the camera, reclining on the floor of a gallery in Dia:Beacon. Dia Art Foundation is closely associated with Minimalist artists Donald Judd, Dan Flavin, and Robert Irwin, to name a few. One cannot overlook the fact that Weems's askance beholding of the yellow monochrome occurs in an institution that has presented only two artists of African descent in exhibitions over the past forty years. She approaches Minimalism and Dia with her long-standing concern regarding, as it was stated in the catalogue for the 2013–14 retrospective of her work, organized by the Frist Center for the Visual Arts, the "ongoing search for answers to questions about where individuals fit within societal constructs," and, one might add, artistic ones as well.

Weems's own presence in the photograph at Dia lays bare the absence of blackness and female blackness from the history and style of Minimalism. Minimalism, one could be led to think, simply cannot hold blackness. But the parameters of Minimalism's preferred style, the monochrome, are placed in Weems's vector of inquisition, for the artist has always used the photographic monochrome, as in her well-known black-and-white photographs, which capture scenes of black love and life and haunt institutional structures in which the concept of blackness was formed, circulates, and gets represented or omitted. The capacity of these works—their very ability to perform as felicitous ocular acts—resides in the affective dimension of Weems's artistic choice. Their levity is possible because Weems privileges the luminance of blackness, evinced in and evanescent of the grays, as opposed to the binary of black and white that refers to the medium itself.

In this portfolio, Weems delivers a sentimental minimalism, folding mono-chromatic color, the concept of blackness, and her interest in beauty by intervening in the images with color in two distinct ways. The works in *Colored People* and *Africa: Gems and Jewels* are not color photographs but *colored* photographs, meaning pigment is not reproduced but rather imbues, envelops, and pervades the images in hues of luminescent violet, azure, sepia, and citrine in the former, and delicate rose, emerald, and indigo in the latter. When installed as *Colored People Grid* (2009–10), the dyed images are situated on the wall in a floor-to-ceiling pristine grid, assembled and interspersed alongside monochrome squares in shades such as eggplant, vermilion, gray, fuchsia, and myriad other tones that make up the forty-two-piece work, each framed in black. Her most recent work, *Blue Notes*, a series of silkscreened panels, takes found images of celebrities, including Rolling Stones singer Claudia Lennear, jazz pianist Thelonious Monk, and vocalist Dinah Washington, and renders them oblique by blurring their visages and overlaying them with single or multiple blocks of primary colors. This artistic move functions to shift our perception and places us more in the field of view of the artist. Weems's radical gesture is to break a pattern in the ways that we typically view certain subjects. We are asked to engage in the questioning with her.

Weems animates minimalism, using color in distinct ways akin to the more conceptual dimensions of performance, or, in other words, what it is that art does in the world, and our relation to it and one another. In all of these works—saturating images with color, foreclosing the legibility of images with blocks of color, and turning her back to the camera—Weems structures visual interludes that suspend and complicate our interpretation of them and their subjects. What she gives are portals for projecting desire, planes of sensual expression, and scenes of the imagination.

With references to abstraction, the artist employs geometry as a formal device and color theory as a logical framework to enable subtle reflection on the illogical constructs of how we frame race and how race frames beings. Weems has said the color works are influenced by a self-reflexive openness that we find in works by artists Mark Rothko and Ellsworth Kelly. However, her priorities and objectives are oriented differently. Color in these works is ornamental, embellishing in order to break through the dimension of the skin, yet acknowledging color and race as vital referents.

Adrienne Edwards is Curator at Performa and a PhD candidate in performance studies at New York University.

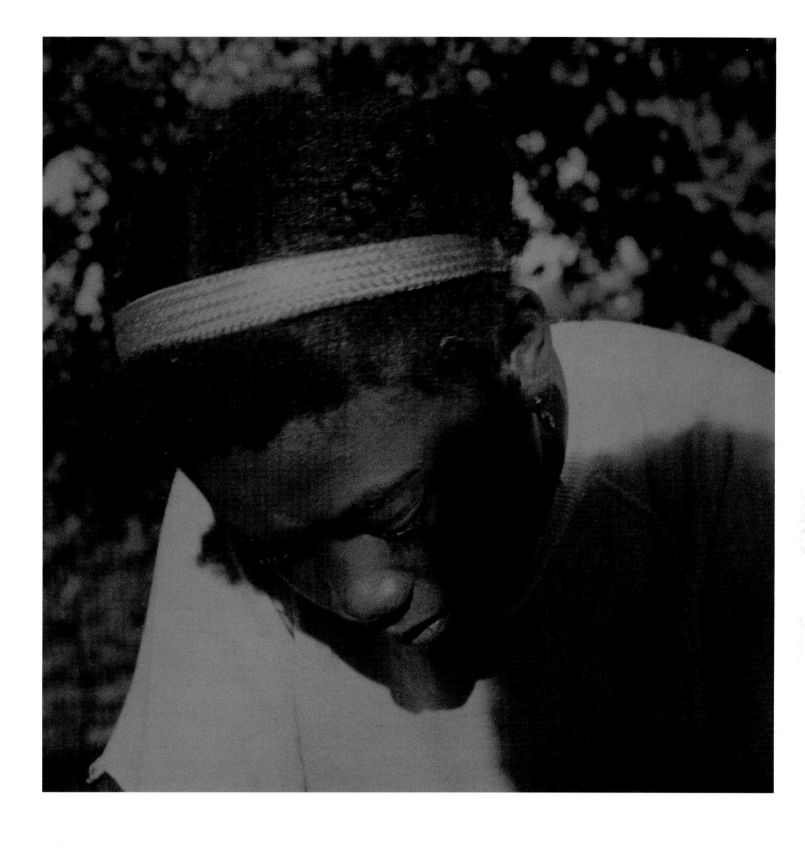

Opposite:
Colored People Grid,
2009-10

This page: *Magenta Colored
Girl,* 1987, from the series
Colored People

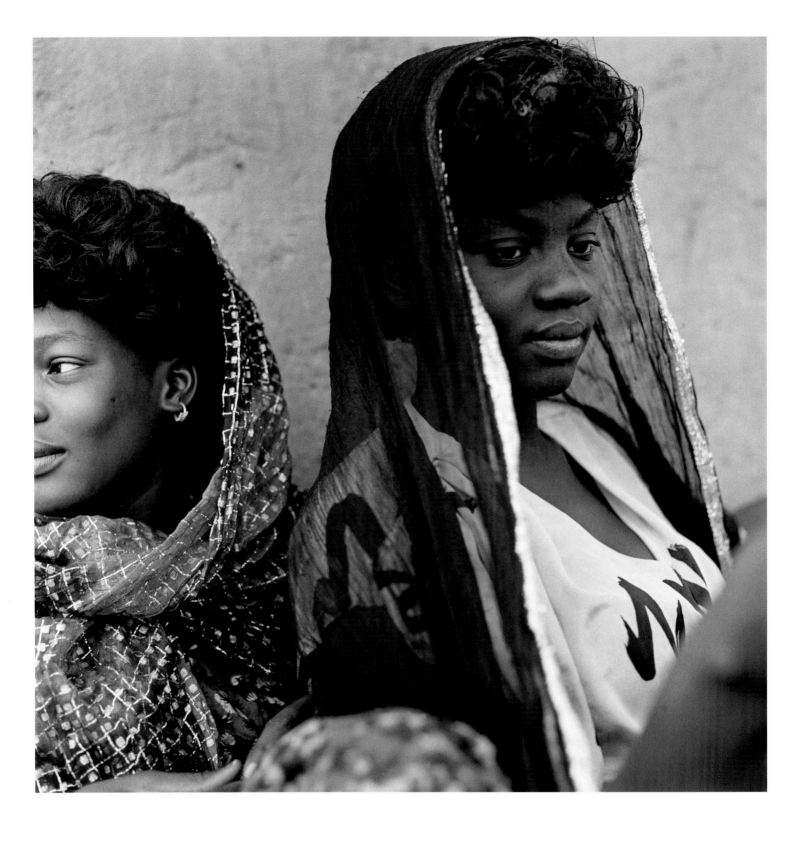

Detail from *Africa:
Gems and Jewels,*
1993/2010

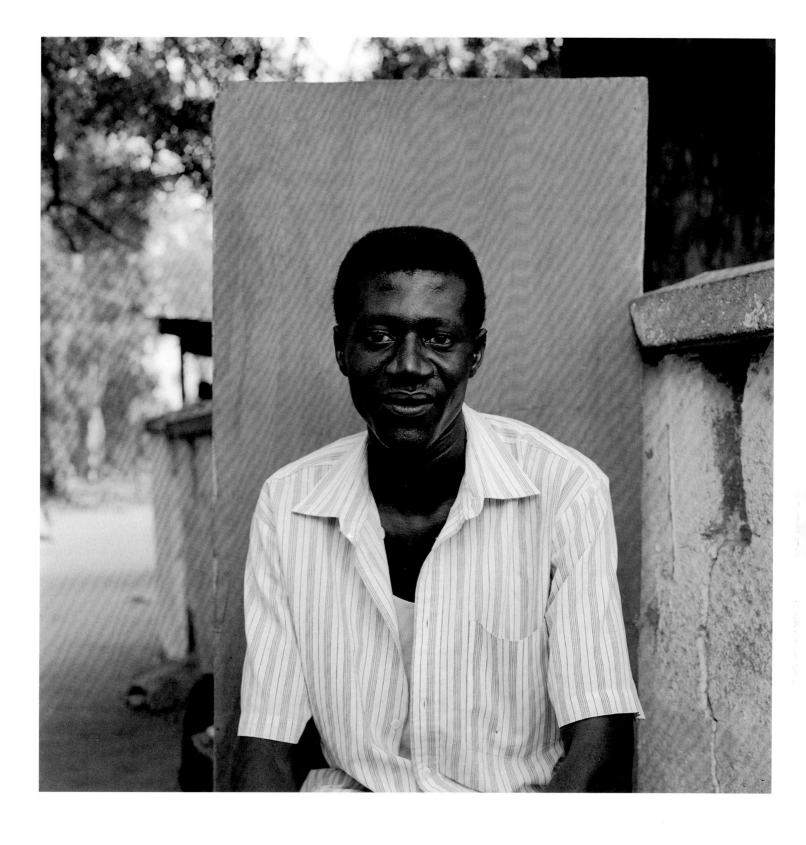

This page:
Detail from *Africa:*
Gems and Jewels,
1993/2010

Page 108:
Claudia, **from the series**
Blue Notes, **2014–15**

Page 109:
Monk, **from the series** *Blue*
Notes, **2014–15**

Pages 110–11:
Color Real and Imagined,
from the series *Blue Notes,*
2014–15
All photographs courtesy
the artist and Jack Shainman
Gallery

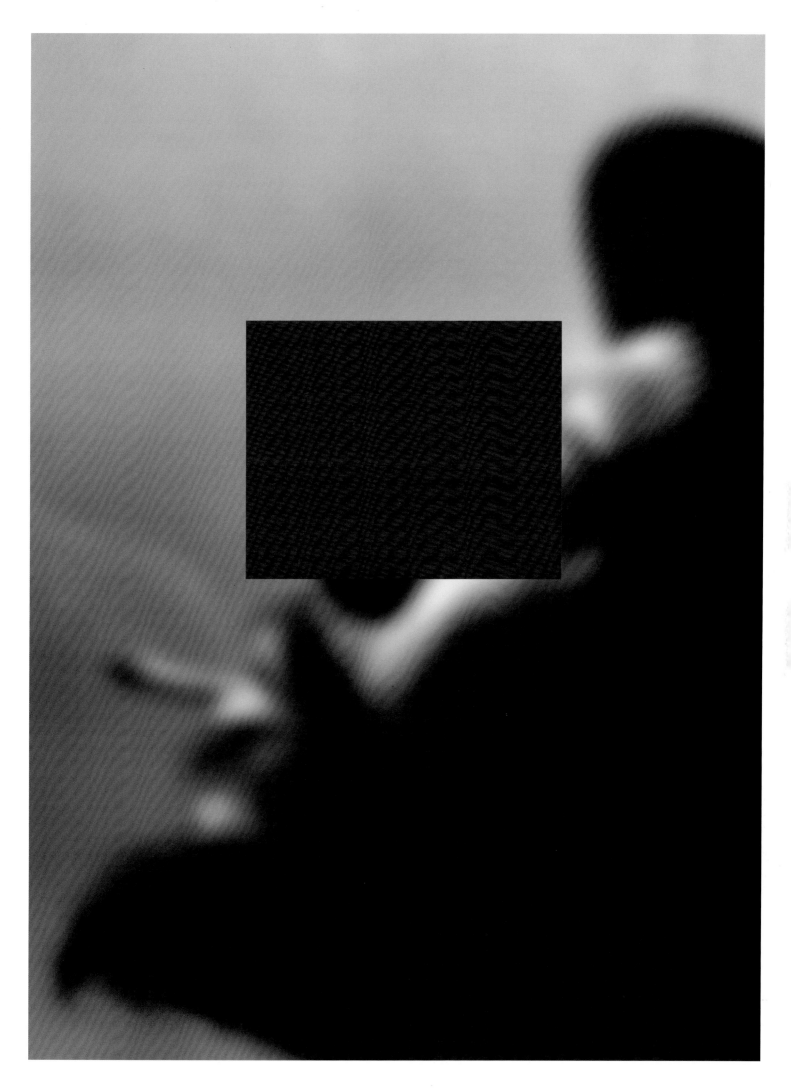

Zheng Mahler is the name of a collaboration between Royce Ng, a Chinese-Australian artist, and Daisy Bisenieks, an Australian anthropologist. Drawing from each other's backgrounds, they apply anthropological approaches to making art and use artistic methodologies in the studies of anthropology. "It might be said that for every great ethnography ever written, there has been another unwritten book which includes the friendships, the gossip, the sex, the fear, and the failure of fieldwork," the duo writes in response to a question about their work, which has included videos about Korean laborers and a musical based on an imaginary academic conference. "All that chaff which is sorted out by the scientific method, which ends up as lecture hall anecdote, seem to us to form the core of what artistic fieldwork or the anthropological exhibition might encompass."

The Hong Kong–based duo is currently engaged in a long-term project exploring transnational trade between Asia and Africa for the Johann Jacobs Museum in Zurich. As a departure point for this subject, they are focusing on a trading hub in Hong Kong called the Chungking Mansions. Built as a large, seventeen-story residential building in 1961, this building now holds three shopping malls and countless guesthouses, and is known for import/export shops that retail objects primarily sold to Asian and African countries. While doing their research, Zheng Mahler developed a relationship with a Somali trader known as the Bull. Together with the Bull they documented the passage of pink abalone from a cooperative of Somali fisherman to the informal dried seafood markets in Hong Kong. Using the Bull's contacts in the self-declared sovereign state of Somaliland, the artists have shipped two metric tons of abalone shells from Berbera to Dubai to Zurich and onward to China as a way of tracing the path of such trading routes.

For their Performa debut, curated by Adrienne Edwards, Zheng Mahler is staging a fictional dialogue between the Bull and a Beijing opera singer. The actors who play these characters bring their own cultural backgrounds into the mix: Kenyan-American actor Irungu Mutu will play the role of the Bull, weaving his own migratory experiences into the text. Kuang-Yu Fong, the artistic director of Queens-based company Chinese Theatre Works, will perform excerpts from her piece *Day Jobs, Opera Dreams*, which is based on the personal migratory and everyday work experiences of Chinese opera singers living in New York, implicating New York City into these circuits of global exchange.

The images seen in the following pages (perhaps the "chaff" referred to above) will be projected during the performance as part of a larger montage of photographs representing Zheng Mahler's research, and include a combination of video stills taken by the artists, images sent to the artists from the Bull by mobile phone, and archival images from New York's Museum of Chinese in America (MOCA), such as the Sun Sing Theatre on East Broadway under the Brooklyn Bridge. This theater was a popular destination for European intellectuals such as French anthropologist Claude Lévi-Strauss, who was a refugee living in New York in the 1940s, and André Breton. Interweaving the histories of Lévi-Strauss, Chinese opera, and Afro-Sino trade relations, among other topics, Zheng Mahler's image archive is a reflection of our current moment, when the world is experiencing the most intense flows of migration since World War II.

—The Editors

Zheng Mahler

Page 114:
Kitty Katz, Sun Sing Theatre, June 1988
Courtesy Museum of Chinese in America (MOCA) Collection

All other photographs courtesy Zheng Mahler

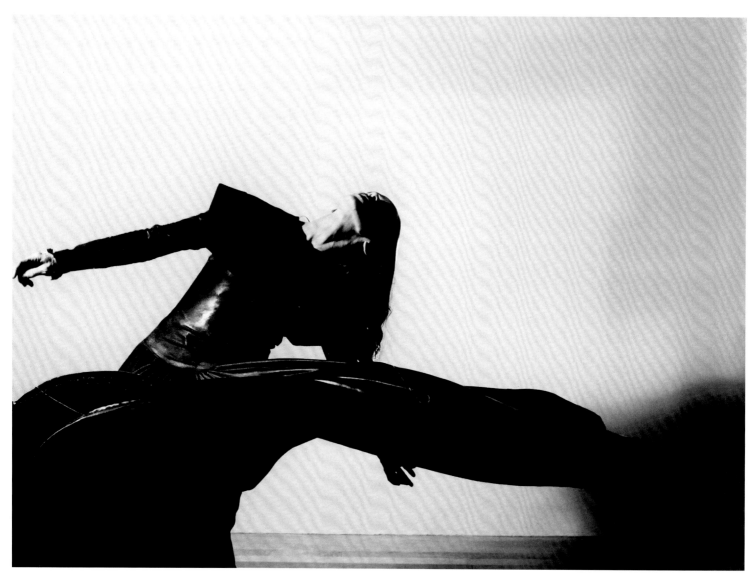

Barbara Morgan, *Martha Graham, War Theme*, 1941

Morgan on Graham/ Mangolte on Brown

Kristin Poor

Kristin Poor is a PhD
candidate focusing on
modern and contemporary
art and performance
at Princeton University.

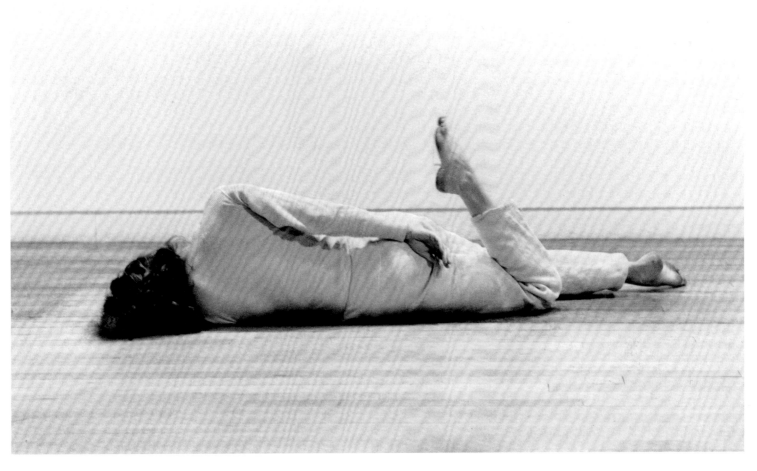

Babette Mangolte,
*Trisha Brown, Accumulation,
Sonnabend Gallery, NYC,
1973*

Martha Graham became emblematic of American modern dance in the 1930s and 1940s, which rejected the artifice of classical ballet, conceiving movement instead, as she put it, as "the condensation of strong feeling." Many of Graham's dances, like *American Document* (1938), drew on American history and mythic themes. In direct opposition to the virtuosic, expressive movement cultivated by Martha Graham and the modern dancers of the intervening generation, Trisha Brown and the other young choreographers, dancers, and artists who, in 1962, formed the Judson Dance Theater, valued inclusivity, everyday, ordinary movement, and chance operations. Brown's dance of the 1960s and 1970s included structured improvisations, additive compositions of "mathematical pieces" like *Group Accumulation in Central Park* (1973), and "equipment pieces," involving ropes and harnesses, using weight and gravity and offering new perspective on the body, as in *Woman Walking Down a Ladder* (1973).

Despite their widely divergent approaches, Graham's percussive emotionality and

Brown's lithe, direct movements are equally resistant to photography's confining stasis. And yet Barbara Morgan's photographs of Graham's work of the 1930s and 1940s and Babette Mangolte's photographs of Brown in the 1970s offer more than fleeting glimpses of gestures. The accomplishments of these two photographers, both artists in their own right, provide defining documents of the differing aesthetics of modern and postmodern dance.

Barbara Morgan met Graham in 1935, the year that Morgan set up her first photography studio in New York, having worked for years as a painter and printmaker in California. Graham and Morgan subsequently began a close collaboration, resulting in Morgan's 1941 book *Martha Graham: Sixteen Dances in Photographs*, which remains an important resource for understanding Graham's choreography today.

To create these photographs of Graham, Morgan approached dance photography as a collaborative studio practice. Observing multiple rehearsals and stage performances, Morgan sought the

"significant gesture" that would "persist in [her] memory" and contain the "very essence of the dance." As she wrote in 1964 in the pages of this magazine, of which she was also one of the founders, "for [her] interpretation it was necessary to redirect, relight, and photographically synthesize what [she] felt to be the core of the total dance." To do so, she would identify a few key movements from a particular piece, discuss them with Graham, and then invite Graham and the dancers to repeat those movements under precisely controlled lighting conditions in her studio until she achieved the envisioned photographic result. Her photographs distill the strong emotive and psychological content of Graham's dances into clearly legible, subjective images. Morgan deployed various strategies to convey movement, including Synchro-flash to arrest Graham's signature swirling skirts and double exposure to suggest the rhythm of repetitive action.

While the technical possibilities and control afforded by studio photography effectively captured Graham's self-described "virile gestures," a different method would be required for Brown's site-responsive and improvisatory dance a few decades later. Shortly after moving to New York from France in 1970, Babette Mangolte began to photograph the performances of Brown and other former members of the Judson group, quickly becoming an important chronicler of the downtown performance scene. (Mangolte is also a cinematographer and a filmmaker, whose films include *Water Motor* [1978], a collaboration with Brown.) For Mangolte, the context of the site and the experience of the spectator of a given performance were paramount in photographing dance, and photography served as a means of understanding what she herself was seeing. Like Morgan, Mangolte would familiarize herself as much as possible with a dance by attending rehearsals prior to photographing it, but rather than moving the dancers to a studio, Mangolte would photograph the performance itself. This entailed overcoming challenges such as low light conditions and unpredictable audience movements in the unconventional spaces—like lofts, public plazas, and rooftops—favored by Brown and the other downtown avant-garde choreographers, artists, and experimental theater directors who also commissioned Mangolte to photograph their performances. For Mangolte, dance and performance photography "requires improvisation, daring, and immediacy," an approach that found its counterpart in Brown's choreography.

Mangolte felt a sense of urgency and responsibility as the photographer because many of the performances were witnessed by only a handful of audience members. Many have observed that Mangolte's photographs have become the defining images of performances from this period, even and especially for those who did not attend them. Also of enduring influence, Barbara Morgan's highly interpretive, synthetic images convey the power, physicality, and drama of Graham's movements, often at much closer proximity than any attendee of a stage performance would have ever enjoyed, and have been used to re-create lost Graham choreography in recent years. Morgan's meticulous dedication to the "significant gesture" and Mangolte's pursuit of "improvisation, daring, and immediacy," well-suited to their respective subjects, leave us with photographs that do more than merely witness. They perform.

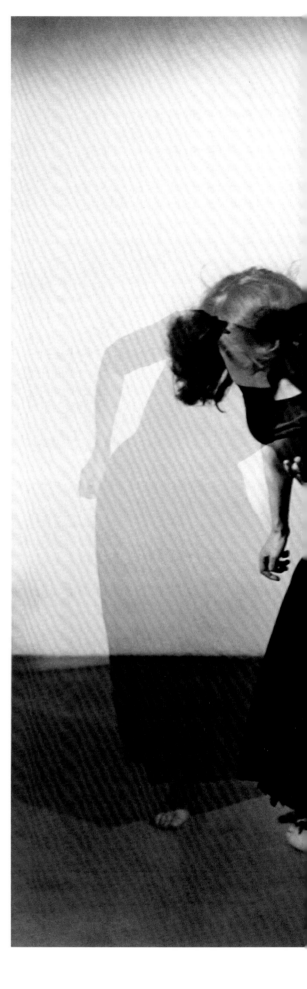

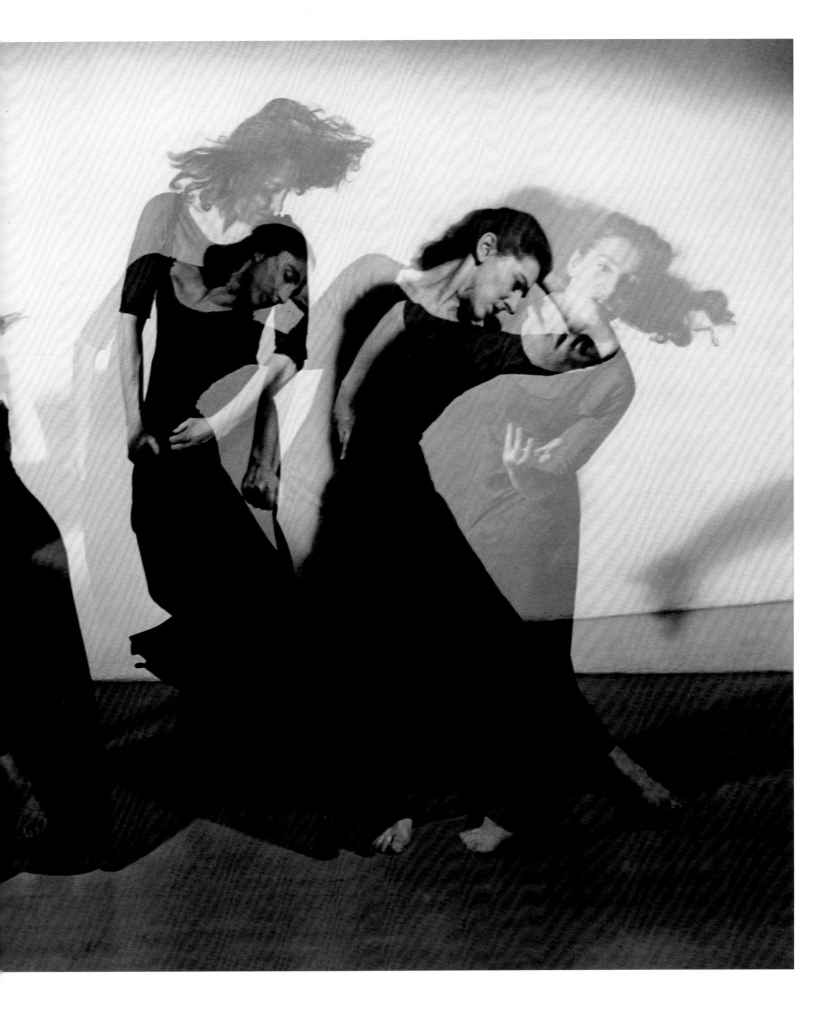

Barbara Morgan,
*Martha Graham, American
Document (trio)*, 1938

Barbara Morgan, *Martha Graham, Celebration*, 1937

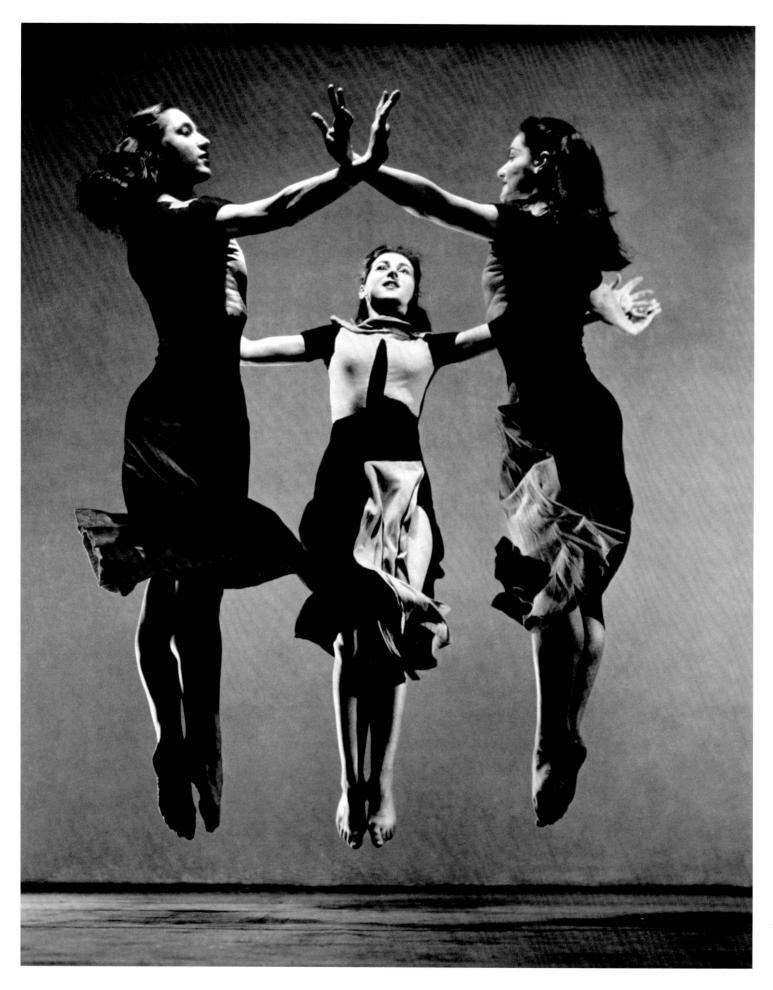

This page:
Barbara Morgan,
Martha Graham,
American Provincials,
1935
Morgan: All photographs
courtesy Barbara and
Willard Morgan, UCLA
Library Special Collections,
and Bruce Silverstein Gallery,
NY

Overleaf:
Babette Mangolte, *Trisha*
Brown, Group Accumulation
in Central Park, May 16,
1973

Pages 126–27:
Babette Mangolte, *Trisha*
Brown, Woman Walking
Down a Ladder, 130 Greene
Street, New York, Feb 25,
1973
Mangolte: All photographs
© 1973 Babette Mangolte

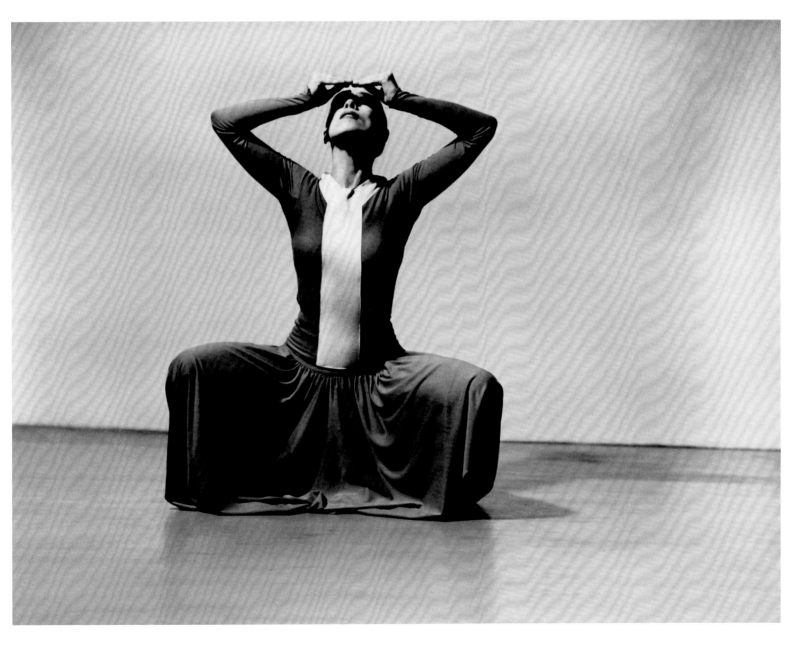

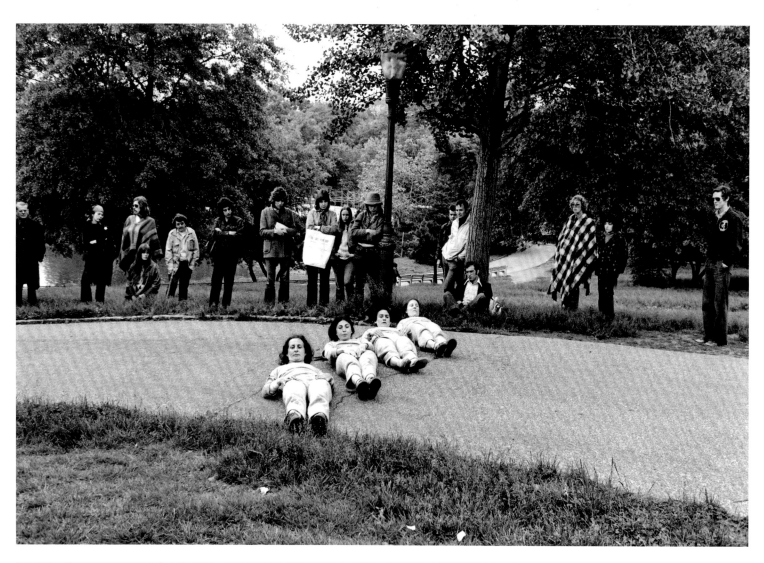

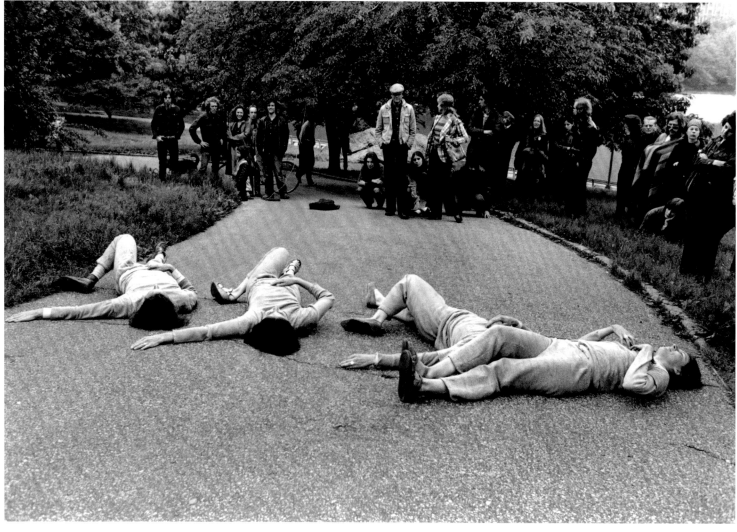

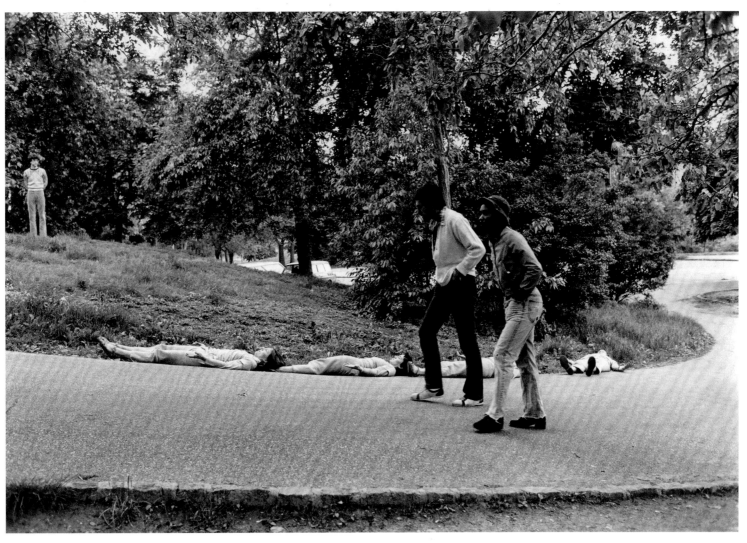

INTRODUCING
THE WINNER OF THE BIENNIAL

Center for Documentary Studies/ Honickman First Book Prize in Photography

AUNTIES

The Seven Summers of Alevtina and Ludmila

Photographs by Nadia Sablin

Available in bookstores November 2015

࿇

With a foreword by prize judge Sandra S. Phillips and an afterword by winner Nadia Sablin

࿇

Created by The Honickman Foundation and The Center for Documentary Studies at Duke University.
Published by Duke University Press and CDS Books of the Center for Documentary Studies.

Object Lessons
John Baldessari's Arm, 2015

Photograph by Molly Berman

Ever since the onset of photography, the roles of the hand and the arm in making art have been subject to doubt. Once the definitive means of bringing an idea into form, these human appendages could seem feeble or quaint in an age of science and industry. Allowing gravity to participate in marking became a vital way to give art a deeper or more objective structure. Marcel Duchamp dropped threads to make the lines of his pivotal 1913–14 work *3 Standard Stoppages*, and Jackson Pollock later dripped paint to push the limits of his control over line. These tactics called attention to art making as a performative grappling with chance and indifference.

In his 1973 series *Throwing Three Balls in the Air to Get a Straight Line (Best of Thirty-Six Attempts)*, John Baldessari brought his impish wit to this modernist turn. He threw three balls in the air in hopes that a snapshot might catch them aloft and aligned. Through the magic of photography, gravity was defeated, and the balls never had to come down. Although he playfully inserted his arm or his finger in other works, in *Throwing Three Balls* he kept himself out of the frame. Well, not quite: his *balls* were in the frame, and the playful reference they make both to his surname and to masculine anatomy is crucial. *Throwing Three Balls* spoofs the swagger of the Pollock myth of a man laying himself bare through his struggle with the elements. Whereas Pollock orbited his canvases on the floor with all the gravitas of a seminal creator, Baldessari sent his tiny planets skyward with a playful toss.

We should remember, however, that *Throwing Three Balls* was a game for two players. While Baldessari threw, his then-wife Carol Wixom operated the camera. Chance became the intersection of their performances, where the scattershot and the snapshot met. Each resulting image depicted a hanging sculpture made from dime-store materials that invoked, in the deadpan innocence of pop, both the lofty aspirations of the moon-shot era and the absurd randomness of the atomic age. As the catalyst of such images, Baldessari's arm became one of the most disarming of his generation.

Robin Kelsey is the Burden Professor of Photography at Harvard University.